ENCHANTED BY PRAIRIE

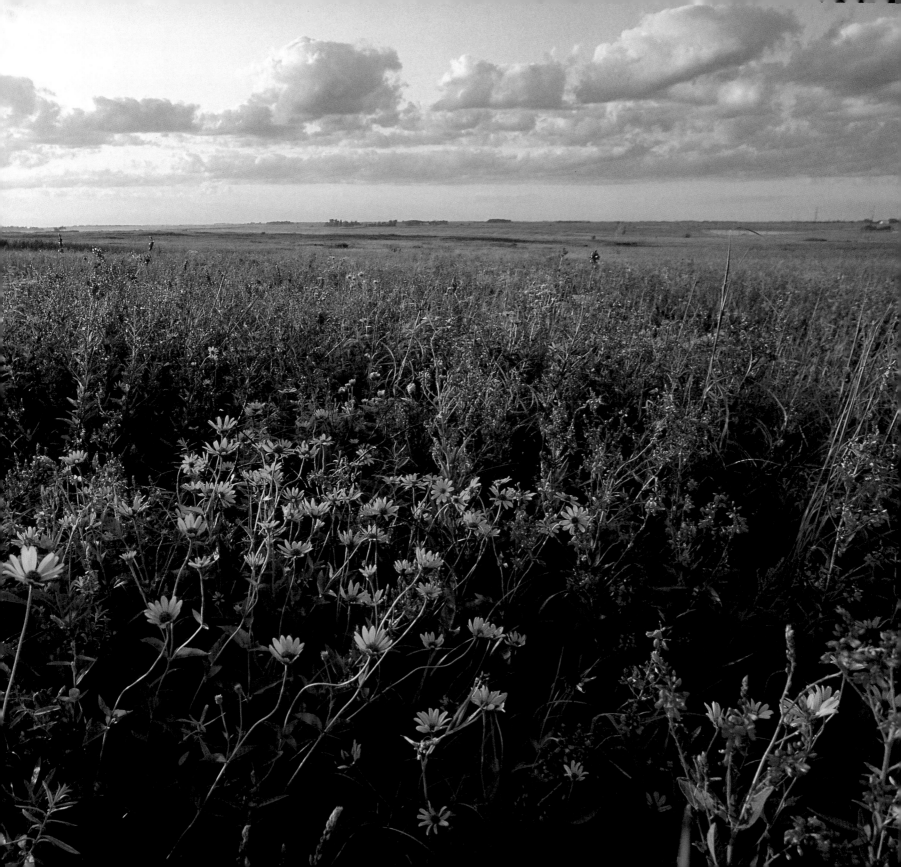

PHOTOGRAPHS BY **BILL WITT**
ESSAY BY **OSHA GRAY DAVIDSON**

Enchanted by Prairie

University of Iowa Press, Iowa City

A Bur Oak Book

University of Iowa Press, Iowa City 52242
Copyright © 2009 by Bill Witt
www.uiowapress.org
Printed in China

Design by Kristina Kachele Design, llc
Composition and layout by Karen Mazur with Kristina Kachele

The University of Iowa Press is a member of Green Press Initiative and is committed to preserving natural resources.

Printed on acid-free paper

Library of Congress Cataloging-in-Publication Data
Witt, Bill, 1950–
Enchanted by prairie / photographs by Bill Witt; essay by Osha Gray Davidson. — 1st ed.
p. cm.—(A Bur oak book)
ISBN-13: 978-1-58729-803-5 (cloth)
ISBN-10: 1-58729-803-1 (cloth)
1. Nature photography—Iowa. 2. Prairies—Iowa—Pictorial works. 3. Witt, Bill, 1950– . I. Davidson, Osha Gray. II. Title.
TR721.W58 2009
779'.36777—dc22 2008040177

09 10 11 12 13 C 5 4 3 2 1

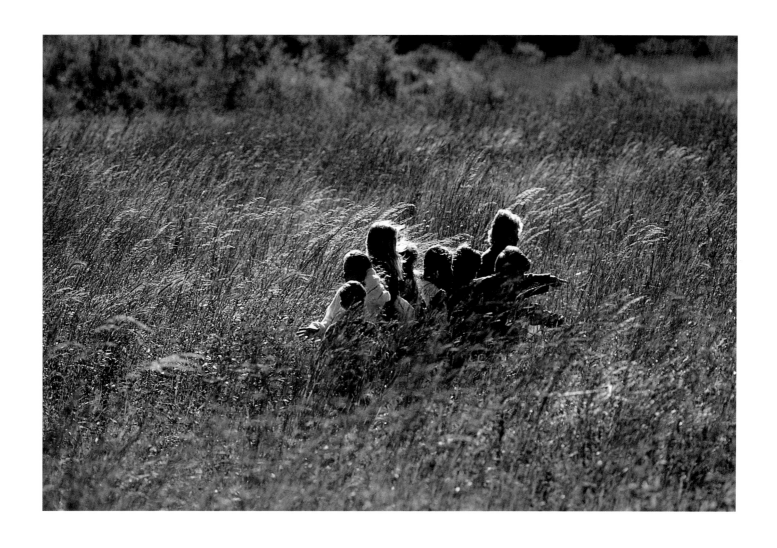

With gratitude to all who have befriended me on my prairie journeys, with hope for all who will follow.

In luminae tua, Domine, vivo.

Contents

HAWKEYE'S WHISTLE, *Osha Gray Davidson* 1

THE PHOTOGRAPHS 9

ENCHANTMENT BY PRAIRIE, *Bill Witt* 79

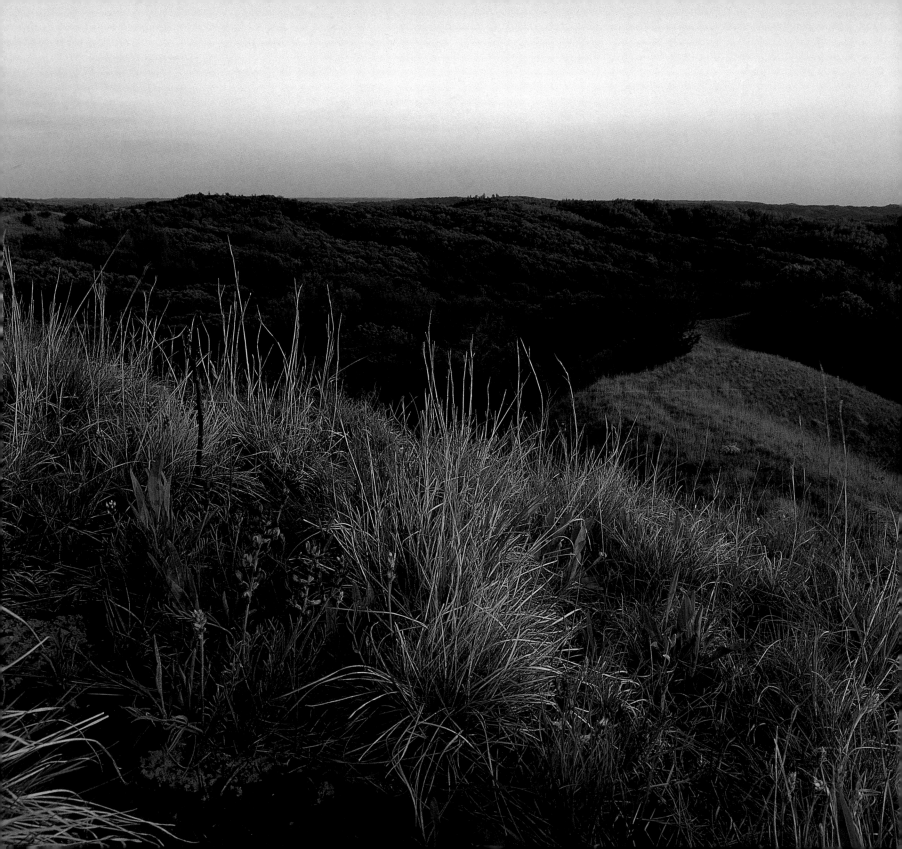

Hawkeye's Whistle

OSHA GRAY DAVIDSON

These days, living far from Iowa as I do, seeing Bill Witt's prairie photographs produces a familiar rush of emotions. First comes the simple joy of seeing the prairie's beauty again. Then comes the wistful tug of nostalgia as all my senses remember the familiar—but now distant—terrain. Even my skin holds its memories: the delight of lying on dried grass in late summer; the satisfaction of rolling a spring stem, plump and smooth, between thumb and index finger; the moist air. During the six years that I've lived in the Sonoran desert, less rain has fallen here than falls in Iowa in a single year. I look at Bill Witt's image of a prairie dawn in early autumn, mist rising in a golden sheet, and my skin remembers the moisture and gives a silent gasp.

 Of all the sense-memories, the strongest is the animal response to smells. Each season on the prairie has its own scents. Spring has the heavy, rich odor of damp soil and, if you get close enough, the lighter, tentative smell of an emerging shoot. Late spring and early

summer are dominated by the scent of flowers, which used to surprise me with their subtlety. (It was years before I understood what was happening. Wildflowers have survived by putting only as much energy into scent production as is required to attract pollinators. Store-bought blossoms are bred for the kind of heavy scents that seduce buyers.) By midsummer you can almost smell the sunlight itself, mediated by photosynthesis. A dry autumn produces a slow, measured withdrawal of scents as plants fade. Few scents can endure a prairie winter. They seem to follow the ground squirrels into their subterranean burrows and hibernate until the air warms and the cycle begins again.

These memories trigger a bittersweet nostalgia, followed by an ache that is simply bitter, like hemlock. I can manage the prairie hunger that results from distance; it's a form of homesickness that can be relieved by visiting Iowa. This other pain seems incurable. It comes from knowing that the Iowa prairie is not just distant but disappearing. And not just disappearing but very nearly gone.

Before the European conquest, Iowa was covered by some 30 million acres of prairie. About one-tenth of one percent remains. The difference between what was and what remains is on the same scale as reducing a basketball court to the size of a chessboard. For five thousand years, a vast prairie covered nearly the entire state of Iowa with flowers and grasses stretching ten feet or more into the air. This is what's left: prairie remnants.

The early American author James Fenimore Cooper would not be surprised. Cooper, who created the character Hawkeye, the rugged frontiersman who provided Iowa with its nickname, would be saddened, but how could he be surprised by a process he predicted? Cooper anticipated these losses in books written a generation before Iowa achieved statehood. One book ends with Hawkeye whistling for his dogs and heading west into the wilderness, fleeing the mindless destruction of the American landscape. In the 1827 novel *The Prairie,* Hawkeye encounters a villainous pioneer family preparing a campsite. The hero watches with loathing as the Bush family methodically fells every tree in sight, until the area looks "as if a whirlwind had passed along the place."

Through a series of popular novels, Cooper tried to reconcile civilization's benefits with the destruction it inevitably brought—to the land and to the people who already occupied it. *The Pioneers: or The Sources of the Susquehanna,* published in 1823, was the first of these books and the one in which Cooper's ironic view of progress is most obvious. It's important to understand Cooper's choice of the word "pioneer," explains literary historian Wayne Franklin in his authoritative biography, *James Fenimore Cooper: The Early Years*. In 1823, the word had not yet acquired its current usage as a synonym for a settler. In fact, the term was apparently hardly used at all. Franklin's research turned up a single publication with the word "pioneer" in its title before Cooper's book.

As Franklin explains, " 'Pioneer' comes from the French *pionnier,* a term for a soldier in a squad sent out ahead of an army to clear the land—especially to cut the trees and brush so the army can make it through or fight the enemy there." Cooper underscores the importance of this word to his theme by placing it strategically within the book. "Pioneer" appears only once in the opening chapter and then not again until the last sentence, in which Hawkeye flees the "wasty ways" of civilization. This is the scene in which Hawkeye whistles for his dogs and heads west, "the foremost in that band of Pioneers who are opening the way for the march of civilization across the continent."

Cooper wasn't opposed to the Euro-American enterprise in the New World. His opinion was more complex. In *The Pioneers* he creates a character to serve as a counterweight to Hawkeye's unquestioning allegiance to pristine wilderness. Judge Templeton shares the frontiersman's disgust for the Bushes of this world. The Judge understands, however, that Hawkeye's solution—whistling up the dogs and disappearing into the wild—is a short-term solution that can be used by very few people. The continent only *seemed* infinite.

The Judge is an early advocate of conservation as an antidote to the excesses of civilization. After gleefully helping villagers haul in a net full of at least a thousand bass pulled from a deep lake, the Judge picks up a large fish. He grows melancholy. "This is a fearful expenditure of the choicest gifts of Providence," he gravely informs his daughter.

"Like all the other treasures of the wilderness, they already begin to disappear before the wasteful extravagance of man." The Judge also looks forward to the day when "the unlawful felling of timber [is] a criminal offense."

Thirty-five years later, in 1858, Henry David Thoreau published an article in the *Atlantic* extending Cooper's argument to include wild areas, calling for a system of "national preserves" to save entire ecosystems—land, plants, animals—"not for idle sport or food," he wrote, "but for inspiration and our own true re-creation." Thoreau's vision became reality with the birth of the National Park System. Unfortunately, "parks" typically meant forested mountains. Other areas, equally rich in flora and fauna or even richer, were left to the not-so-tender mercies of the marketplace. In Iowa, the result is the scattering of prairie remnants.

Just like "pioneer," the word "remnant" has a history. It, too, derives from French, *remenoir*: "what remains." A remnant is defined by what no longer exists, and so it searches in the past for meaning. Jews and Christians, however, have for millennia redirected the word from the past to the future. After the Assyrians conquered the Israelites (along with just about everyone else in that contentious neighborhood), the prophet Isaiah saw brighter times ahead. "For though thy people of Israel be as the sand of the sea," he prophesied, "yet a remnant of them shall return." Throughout the

Hebrew scriptures, "remnants" of the faithful are continually reconstituting the Jewish people. Early Christians adopted this use of the word "remnant" in Acts 11:5 according to their new interpretation, that is, Jews who have turned to the teachings of Jesus. Later Christians applied the word "remnant" to themselves, the faithful minority who would be saved on Judgment Day. In all cases, the principle was the same: the few, the overlooked, the seemingly insignificant—*that* is where the future lies.

After seeing Bill Witt's wondrous images for the first time, my emotions ran their course, eventually flowing into that ocean of pain familiar to anyone who cares about the natural world. As I continued looking at them, however, I found that I could choose to see them differently. If I tried, I could see these prairie photos existing in the present, with all their past beauty and scents and textures and sounds intact. Despite the well-worn channel, I didn't need to allow my emotions to flow to the past, to the pain of what no longer exists. With that groove blocked, my emotions had to carve a new channel, this one moving forward instead of back.

Perhaps prairie remnants, like their theological counterparts, are awaiting the day when we come to our senses—figuratively and literally. Why not? A growing number of farmers realize that industrialized agriculture is not sustainable. *Something* will eventually replace these monocropped fields of corn. I don't foresee an Iowa returned all to prairie, and

I don't desire it. But in a sustainable future, where humans are well situated for the long haul, large tracts of prairie can restore a natural balance to a landscape almost entirely fabricated by humans.

Iowa may yet become the Hawkeye state, but it will have to earn the name this time. If that happens, maybe we'll hear Hawkeye whistle for his dogs once more. Only this time it won't be the sharp note of grief and anger that flies over the prairie. Hawkeye's whistle will be light and joyous, calling us home to Iowa.

The Photographs

SUNRISE, CEDAR HILLS SAND PRAIRIE STATE PRESERVE.

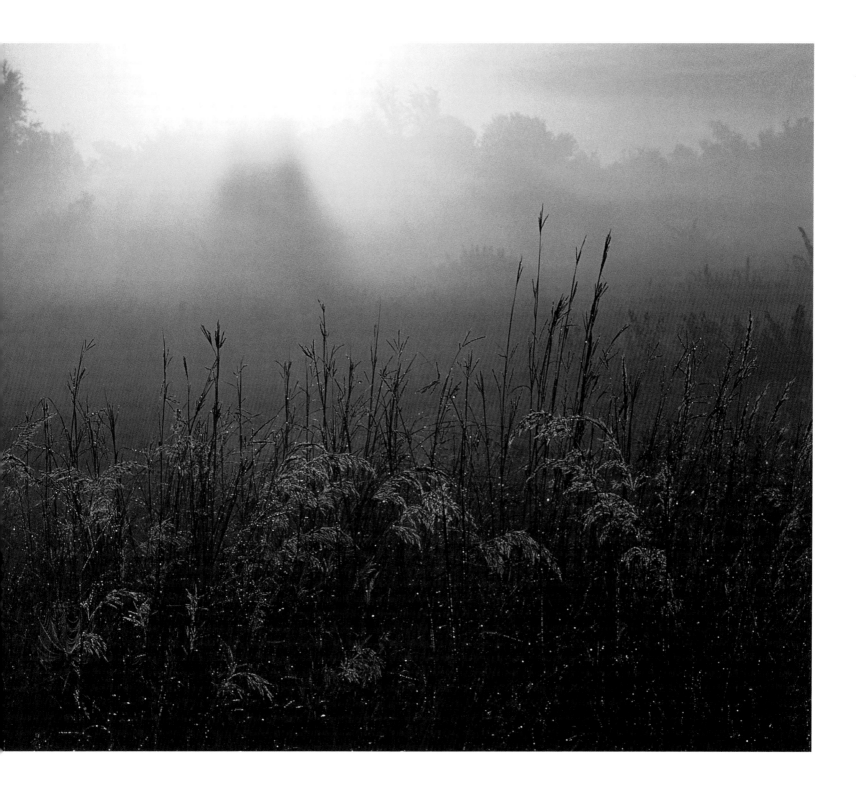

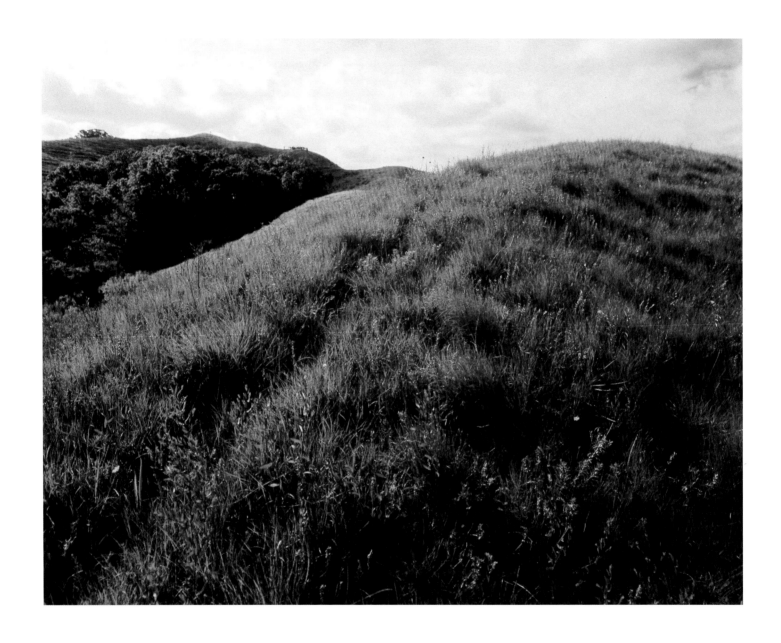

LOCOWEED, SYLVAN RUNKEL STATE PRESERVE.

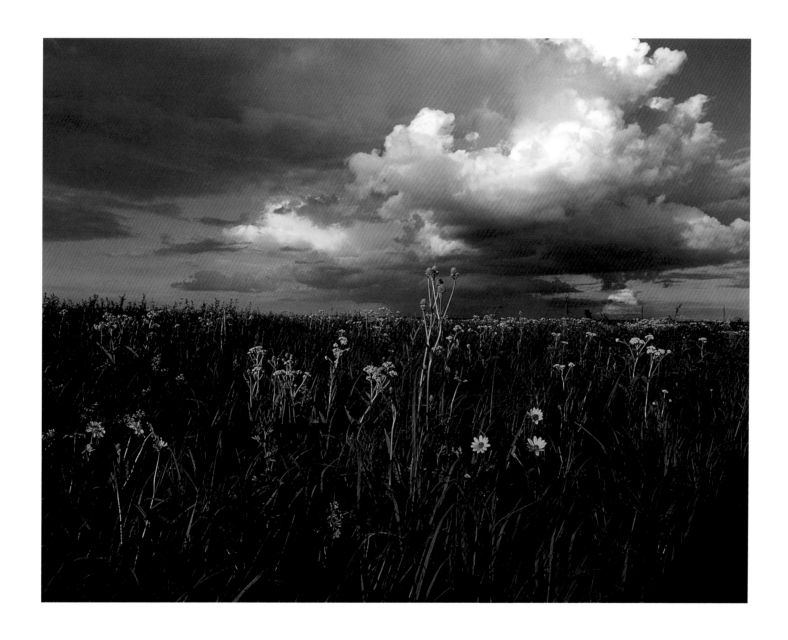

RATTLESNAKE MASTER AND PASSING SHOWER, HAYDEN PRAIRIE STATE PRESERVE.

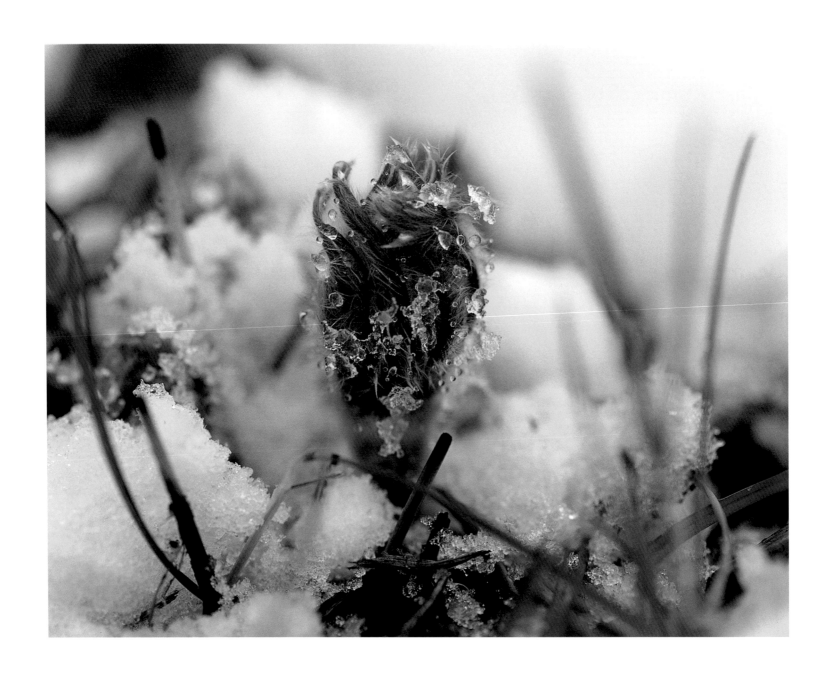

ICE-COVERED PASQUE FLOWER SHOOT, CEDAR BEND SAVANNA.

Opposite: WOOD LILY, BEDSTRAW, AND PHLOX, HAYDEN PRAIRIE STATE PRESERVE.

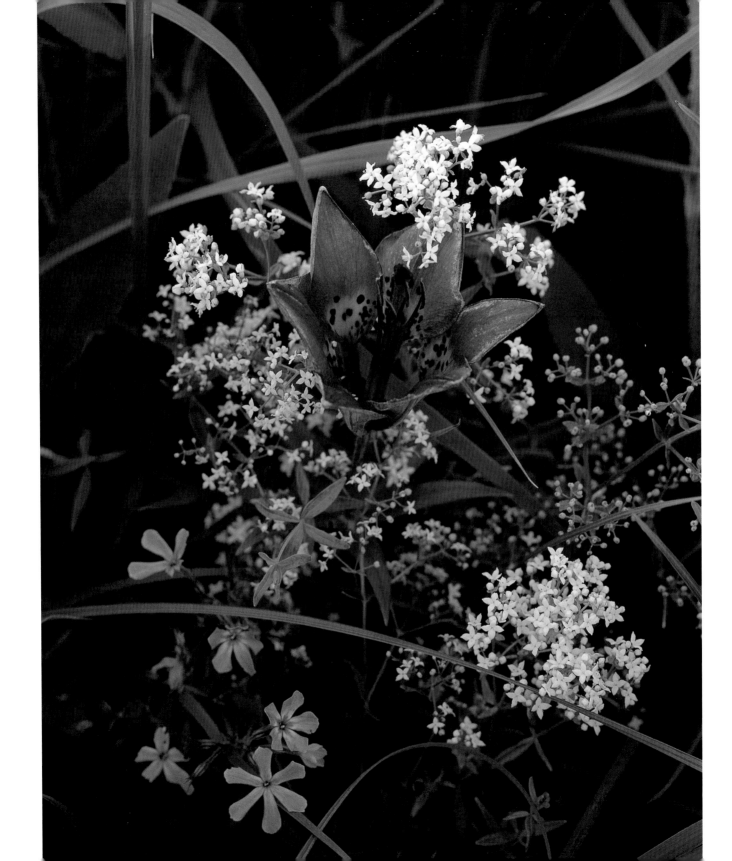

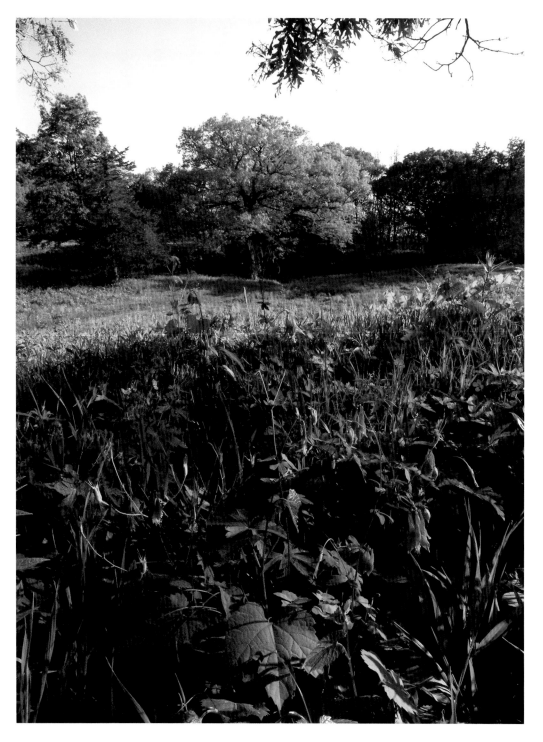

COLUMBINE AND WILD GERANIUM,
ROCHESTER CEMETERY PRAIRIE.

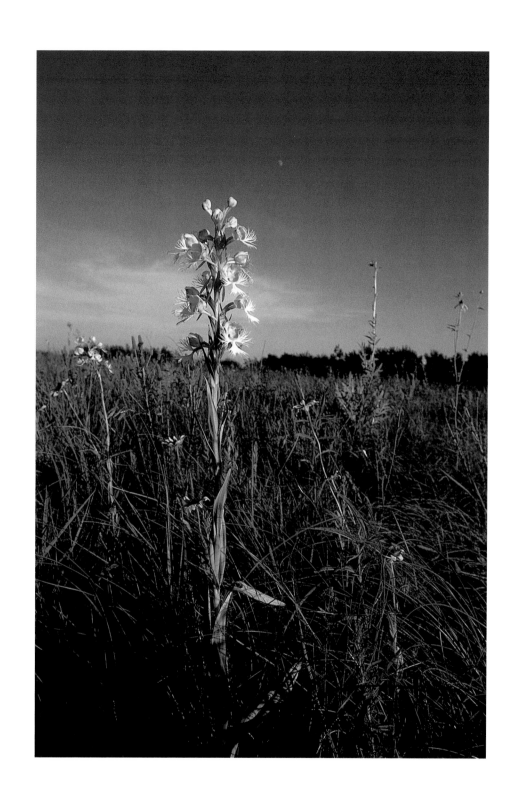

WESTERN PRAIRIE FRINGED ORCHID,
HAYDEN PRAIRIE STATE PRESERVE.

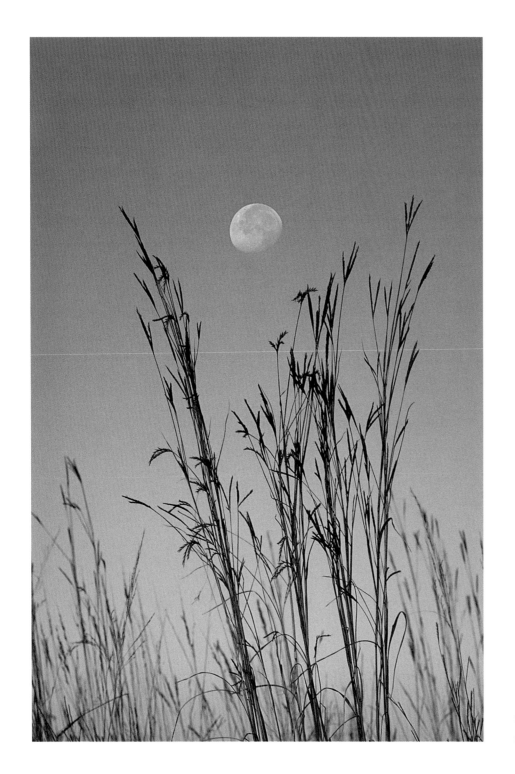

BIG BLUESTEM AND SETTING MOON,
CEDAR HILLS SAND PRAIRIE STATE PRESERVE.

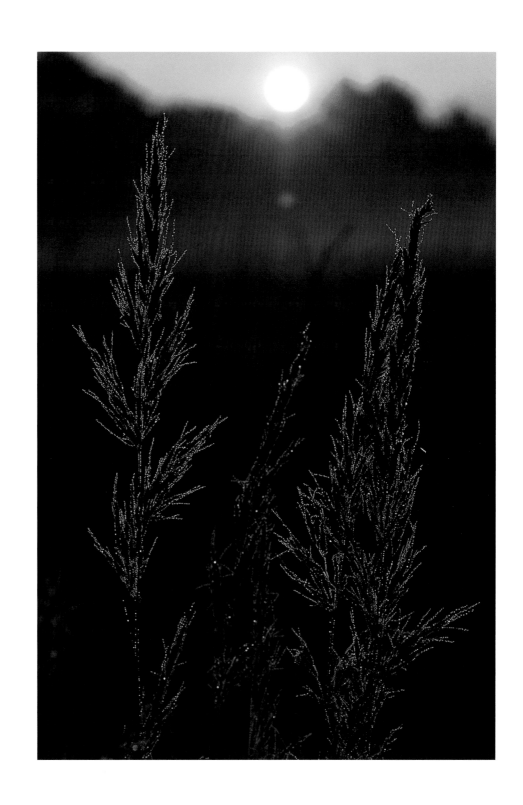

INDIAN GRASS AT SUNRISE, UNIVERSITY
OF NORTHERN IOWA PRAIRIE PRESERVE.

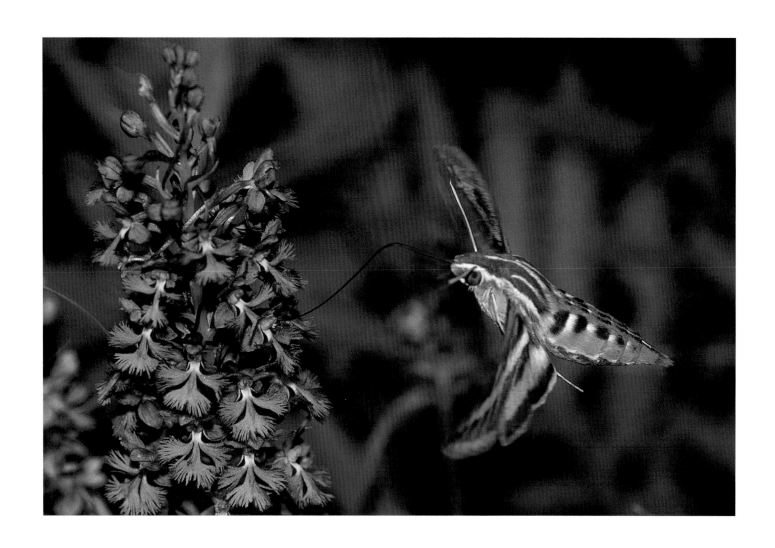

HAWK MOTH NECTARING ON PURPLE FRINGED ORCHID, RICHTER PRAIRIE.

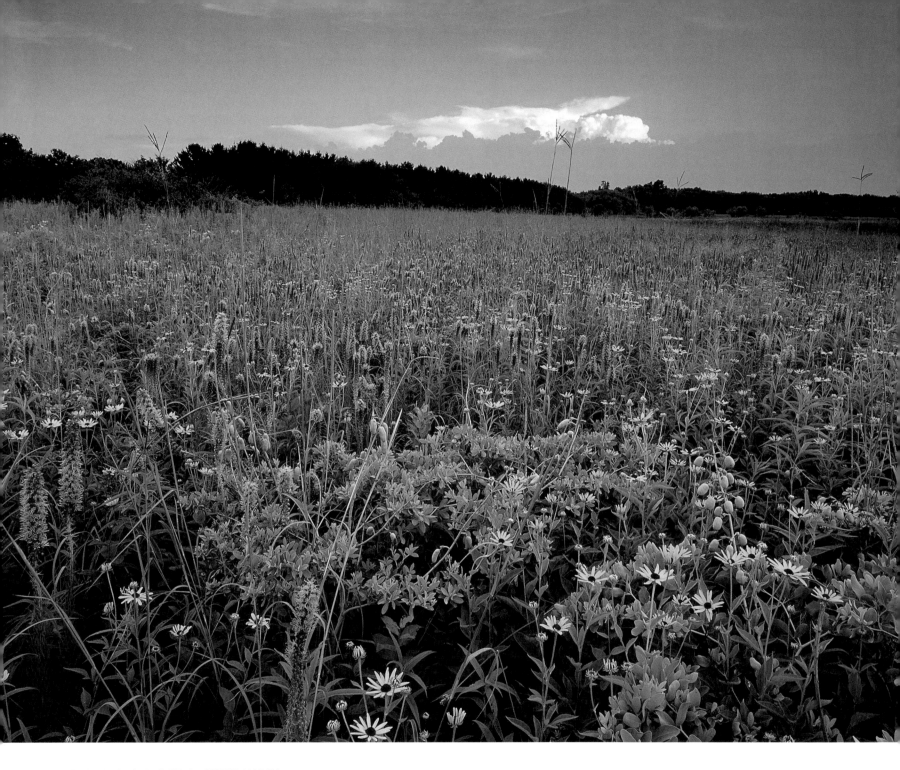

PRAIRIE BLAZING STAR, SWEET MARSH.

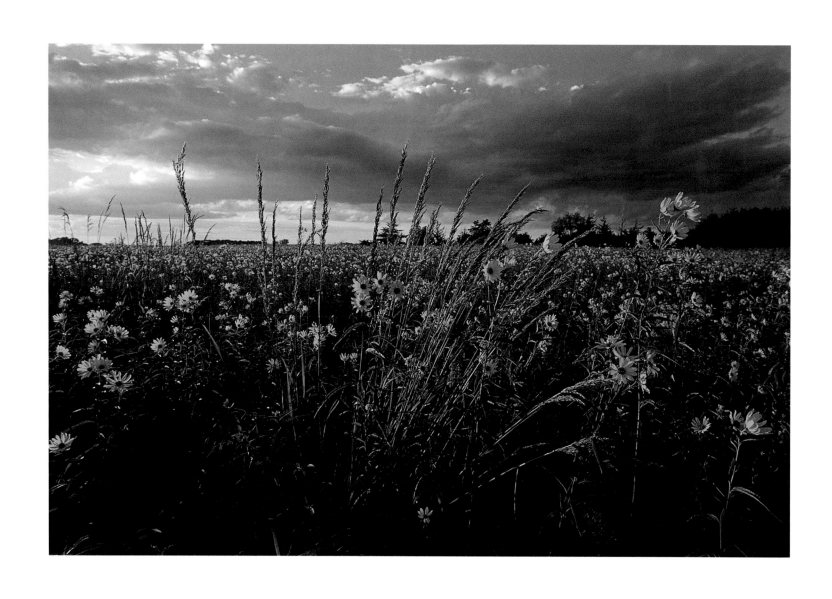

INDIAN GRASS AND SAW-TOOTH SUNFLOWER, CEDAR HILLS SAND PRAIRIE STATE PRESERVE.

Opposite: INDIAN GRASS AND BIG BLUESTEM.

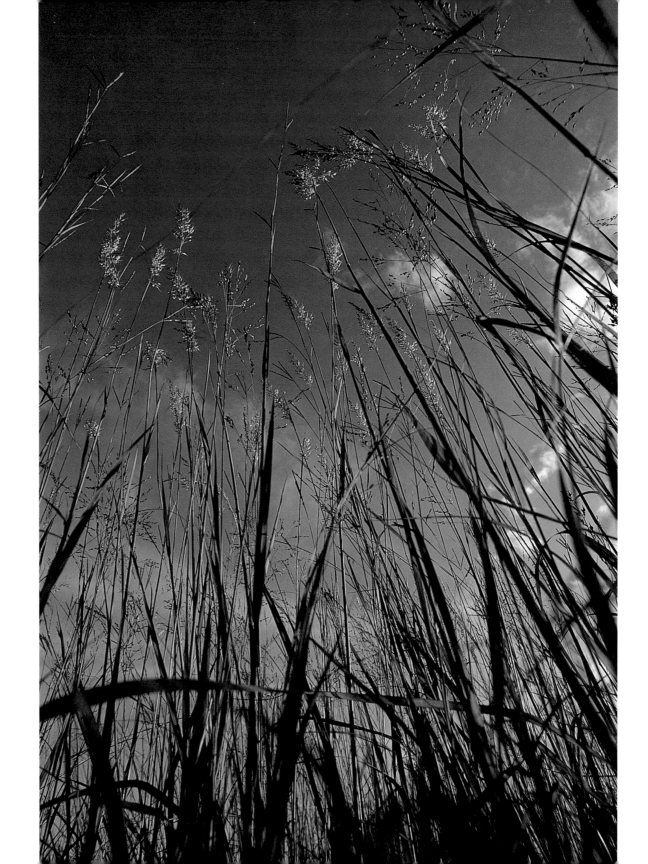

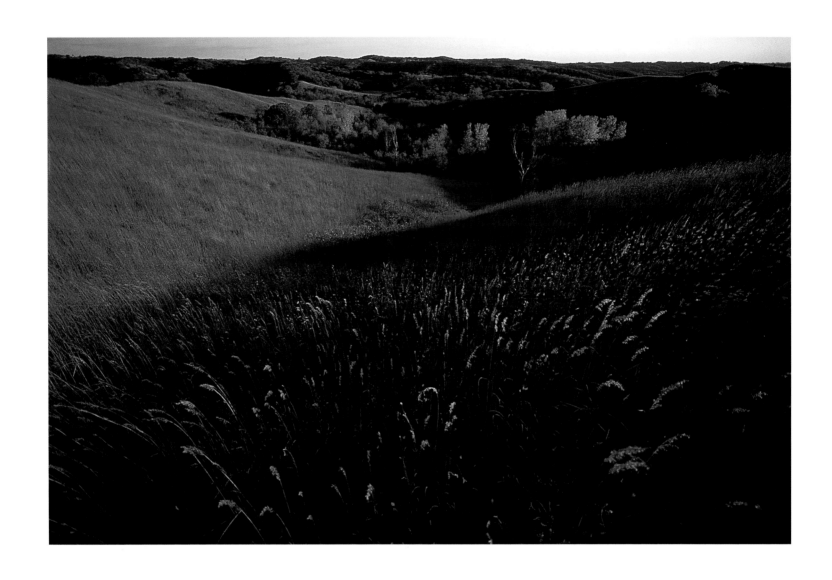

SYLVAN RUNKEL STATE PRESERVE.

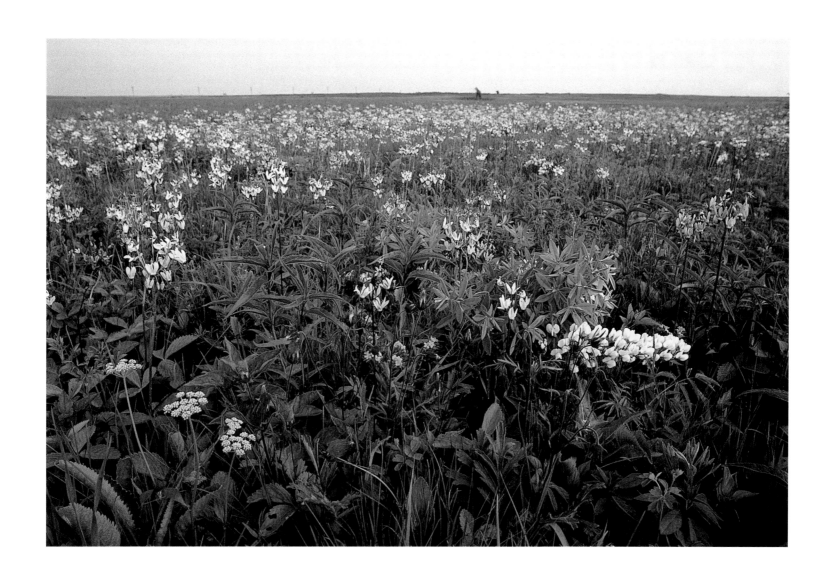

PRAIRIE SMOKE, GOLDEN ALEXANDERS, CREAM WILD INDIGO, AND HOARY PUCCOON.

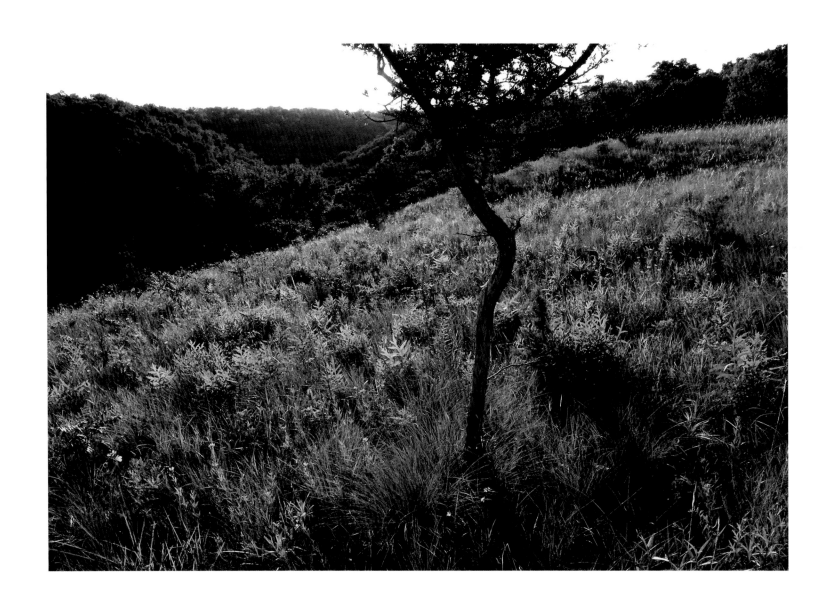

HILL PRAIRIE, UPPER IOWA RIVER VALLEY.

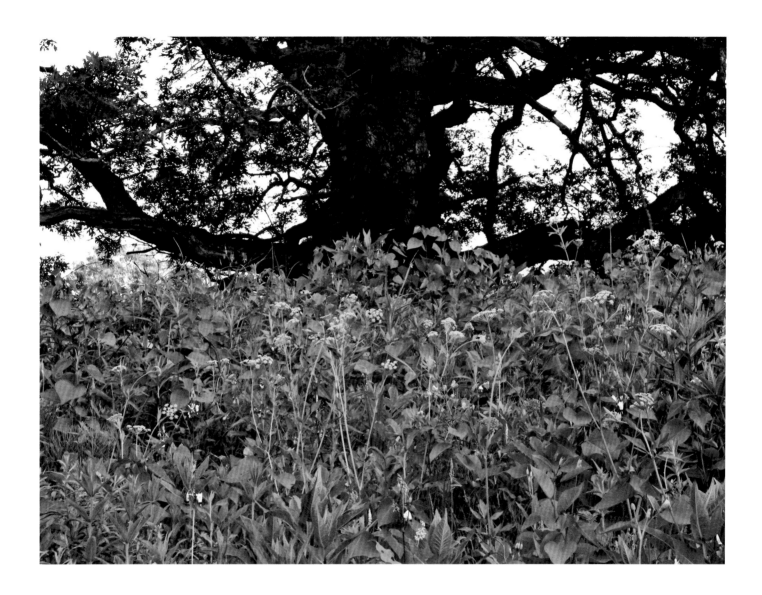

BUR OAK AND EARLY SPRING FLOWERS, ROCHESTER CEMETERY PRAIRIE.

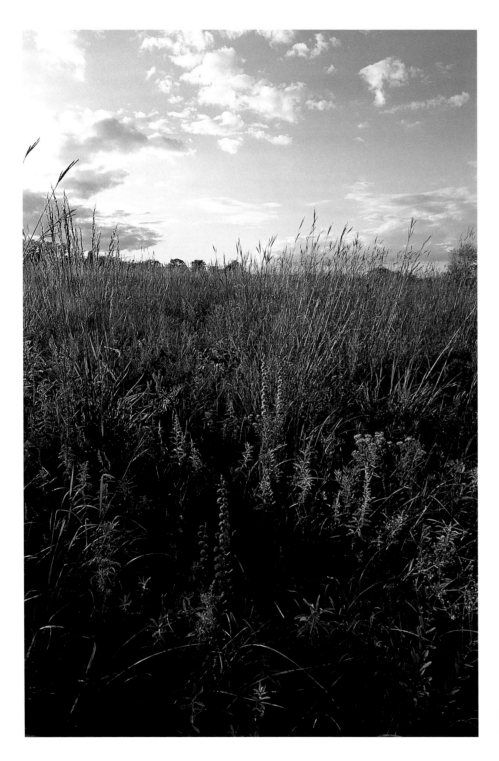

PRAIRIE BLAZING STAR, SAGE, AND BIG BLUESTEM,
CEDAR HILLS SAND PRAIRIE STATE PRESERVE.

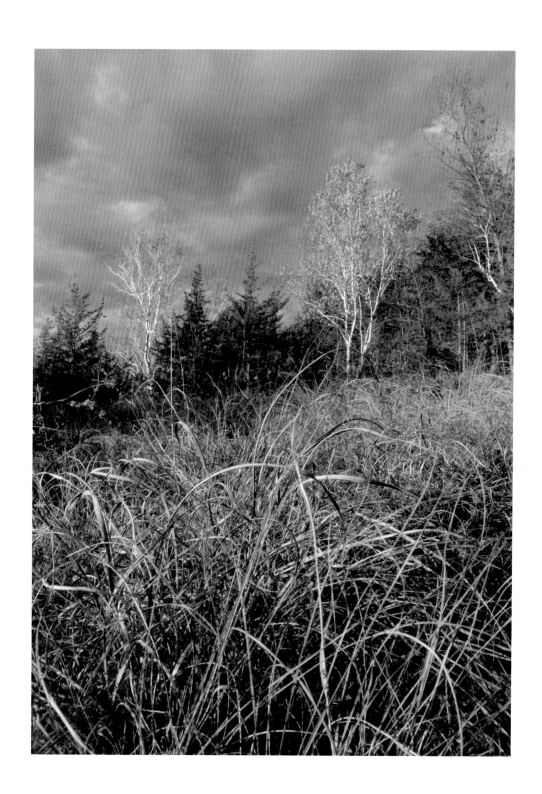

PRAIRIE GRASSES AND ASPENS ON HILL
PRAIRIE, UPPER IOWA RIVER VALLEY.

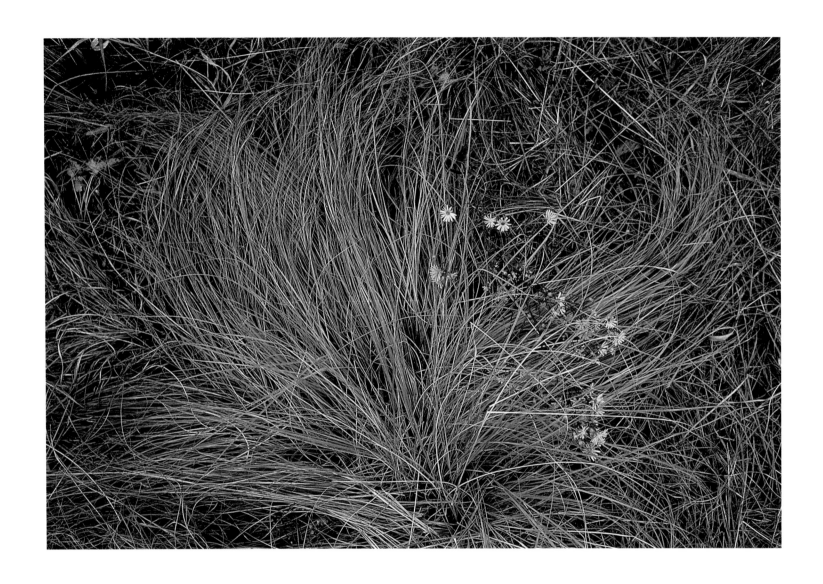

PRAIRIE DROPSEED AND NEW ENGLAND ASTER.

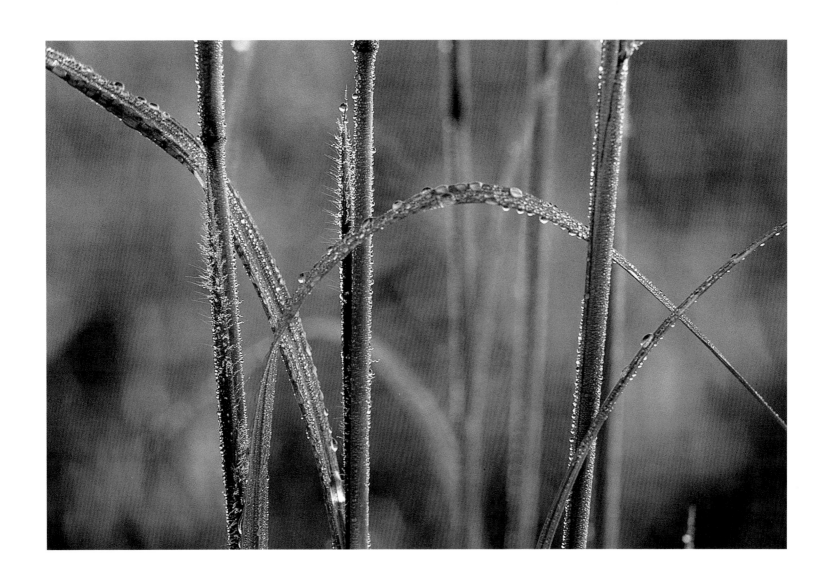

BIG BLUESTEM, CEDAR HILLS SAND PRAIRIE STATE PRESERVE.

SANDHILL CRANE, HAM MARSH.

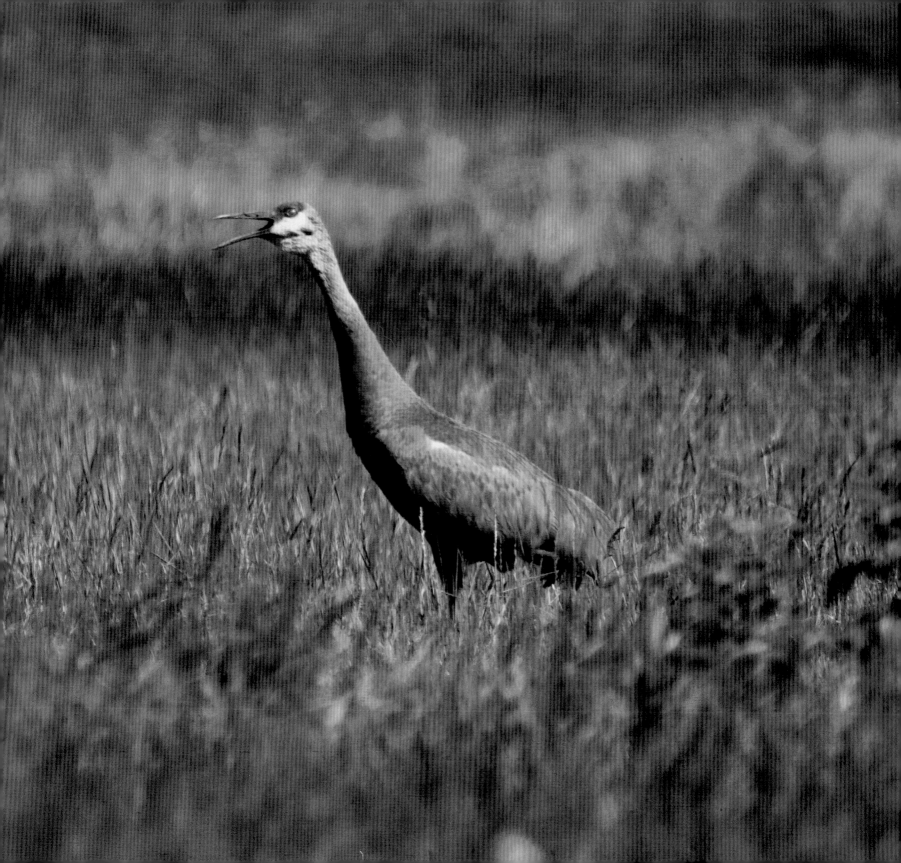

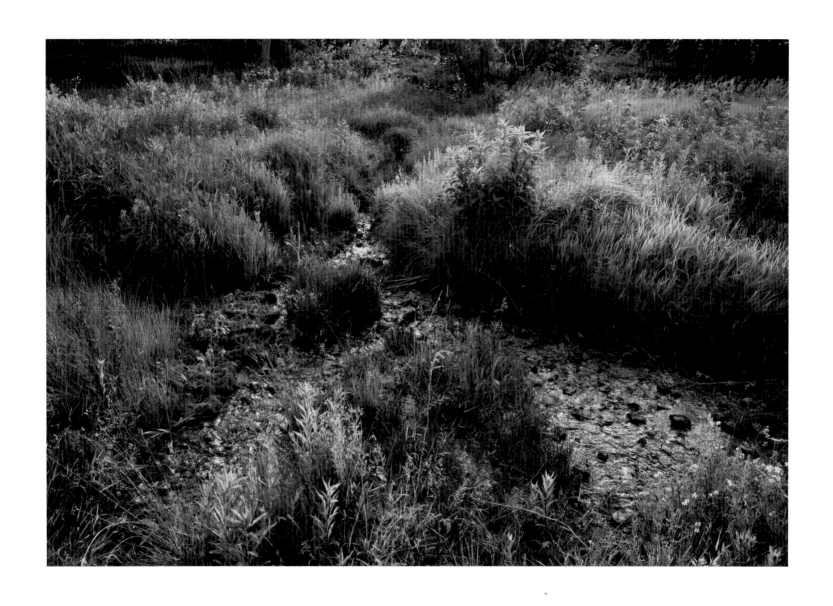

TWIN SPRINGS, BLACKMUN PRAIRIE.

Opposite: MARSH MARIGOLD, SPLIT ROCK PRESERVE.

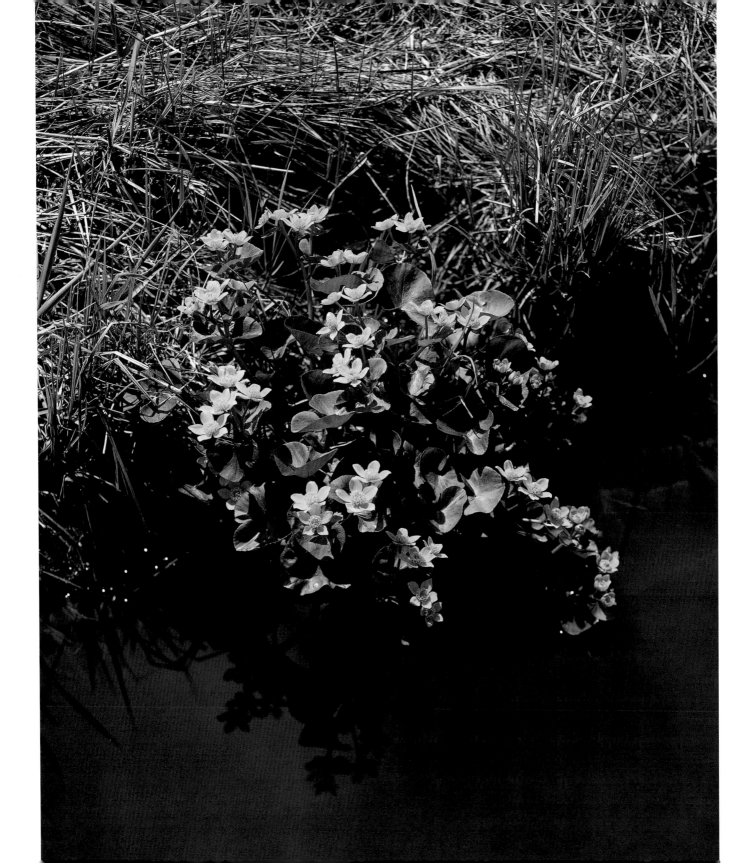

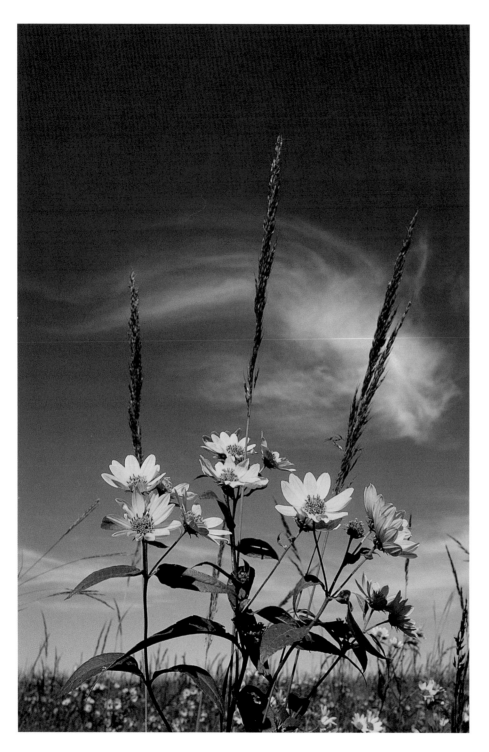

TALL SUNFLOWER, HAYDEN PRAIRIE
STATE PRESERVE.

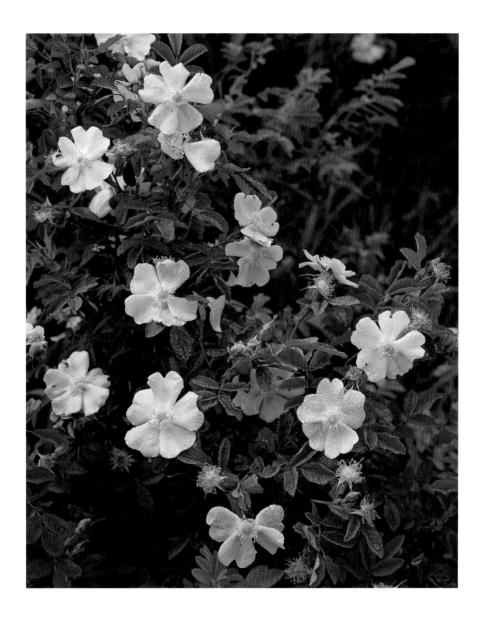

PASTURE ROSE, BLACK HAWK COUNTY.

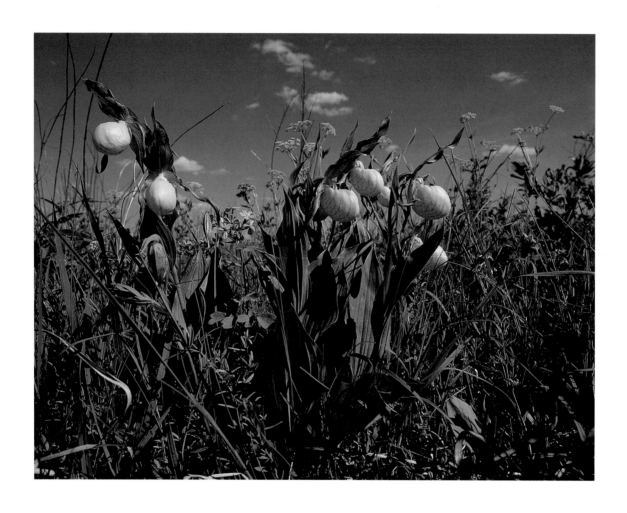

YELLOW LADY'S-SLIPPER, HAYDEN PRAIRIE STATE PRESERVE.

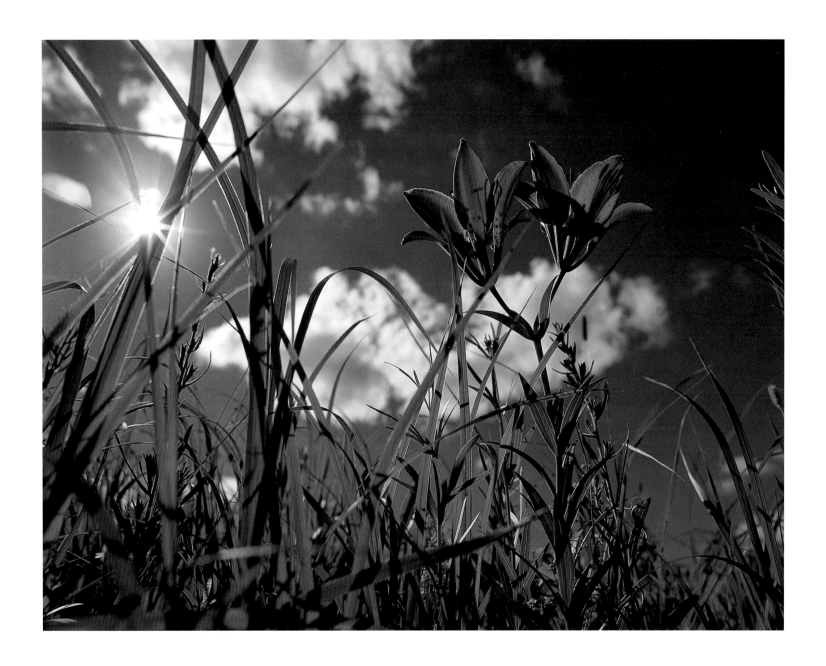

WOOD LILY, HAYDEN PRAIRIE STATE PRESERVE.

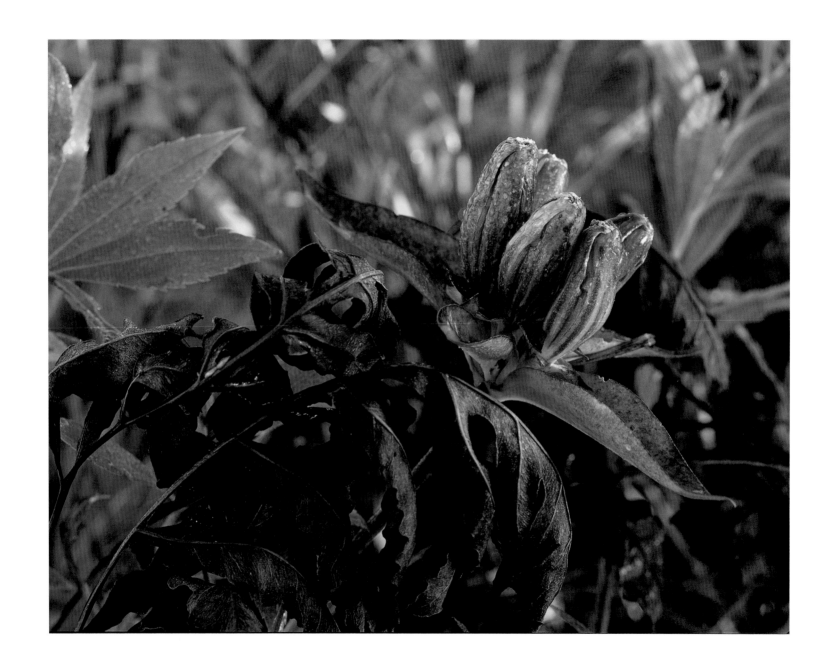

BOTTLE GENTIAN, CEDAR HILLS SAND PRAIRIE STATE PRESERVE.

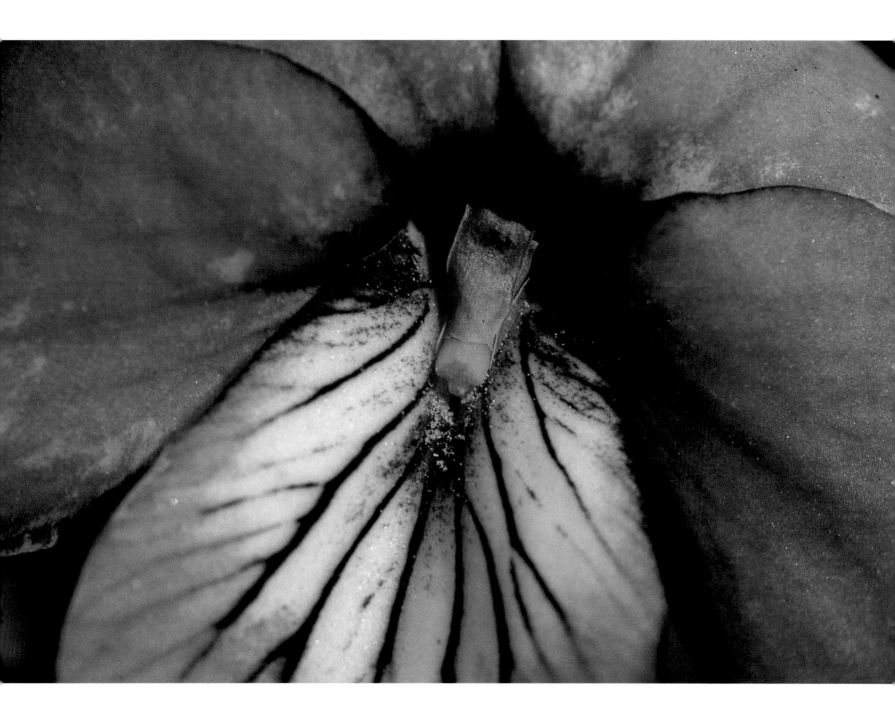

BIRD'S-FOOT VIOLET.

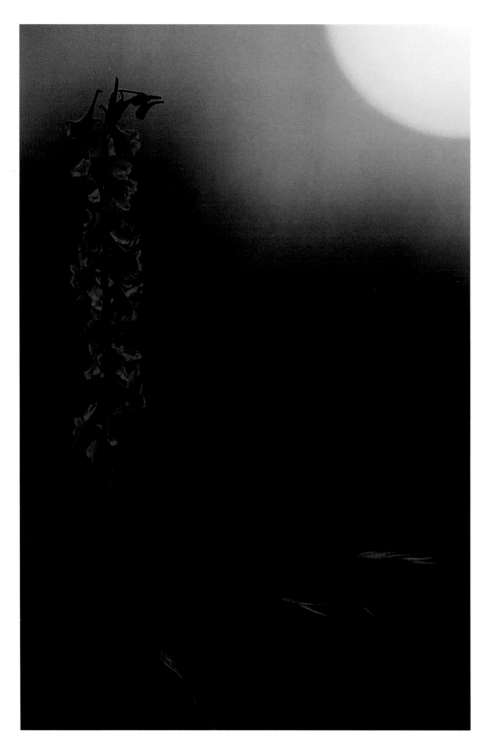

PORCUPINE GRASS AND PRAIRIE LARKSPUR.

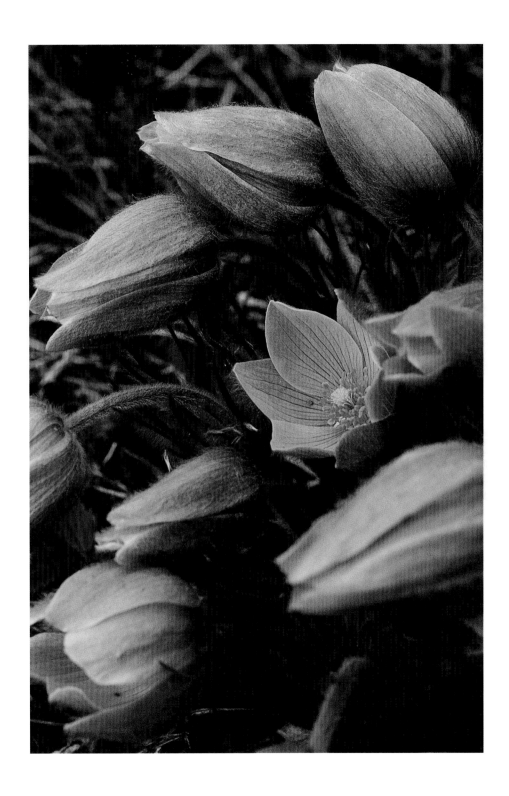

PASQUE FLOWER, CEDAR BEND SAVANNA.

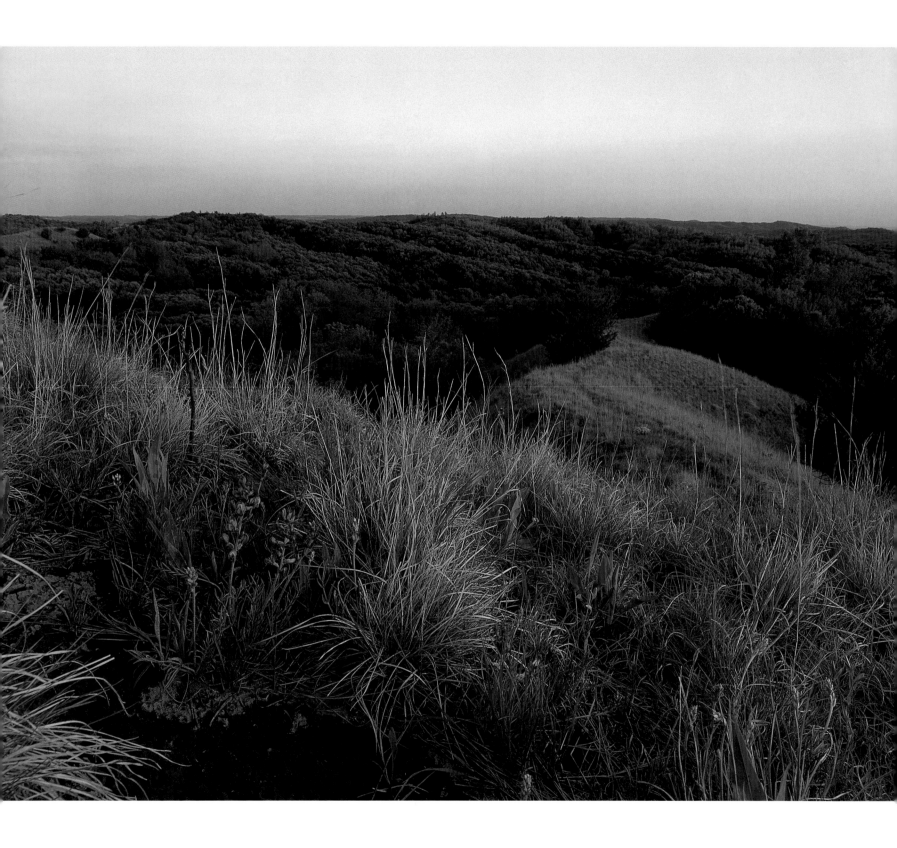

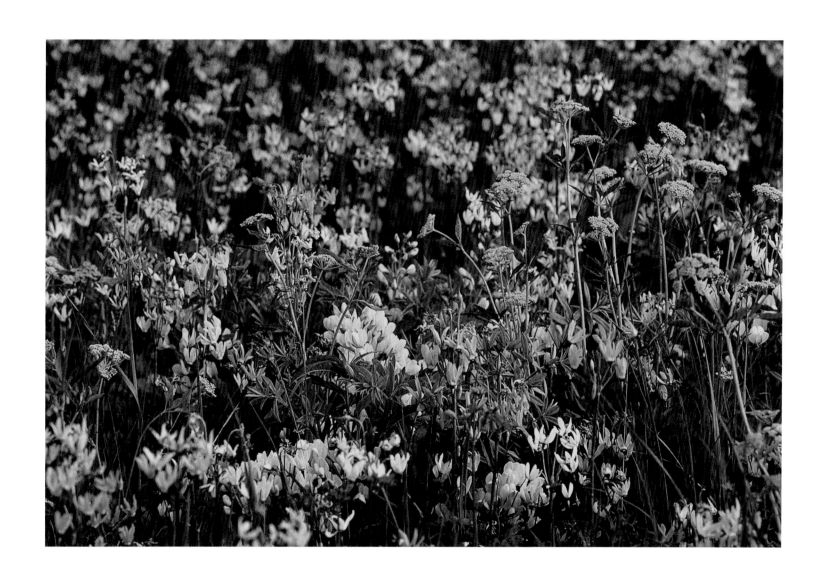

SHOOTING STAR AND GOLDEN ALEXANDERS.

Opposite: LOCOWEED, PREPARATION CANYON STATE PARK.

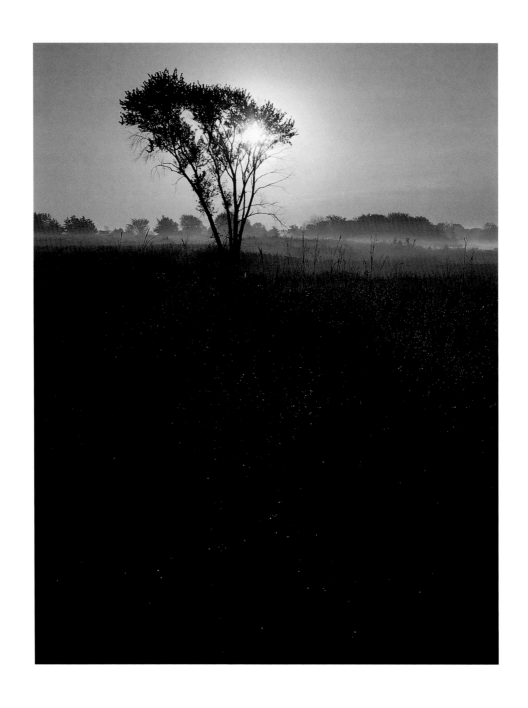

SILVER MAPLE AT SUNRISE, CEDAR HILLS SAND PRAIRIE STATE PRESERVE.

Opposite: COTTONWOOD AND LITTLE BLUESTEM, KAUFMANN AVENUE PRAIRIE.

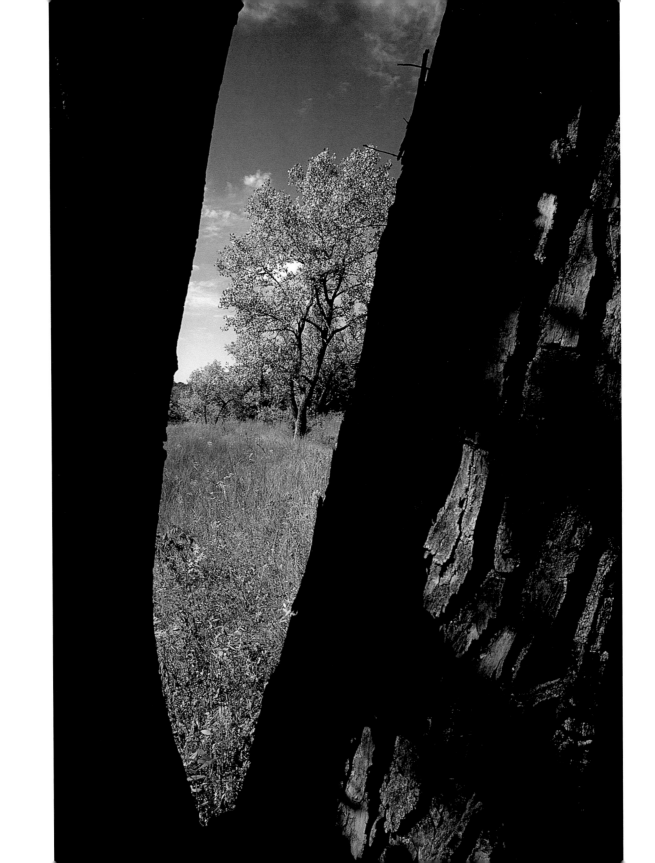

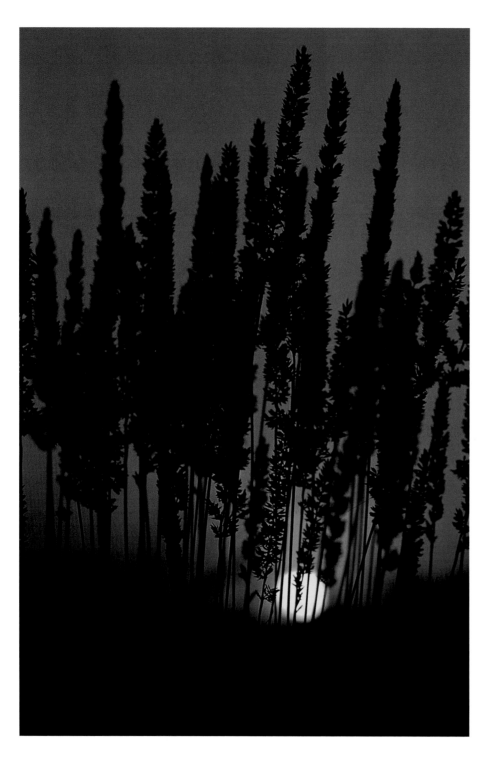

JUNE GRASS AT SUNSET, CEDAR HILLS
SAND PRAIRIE STATE PRESERVE.

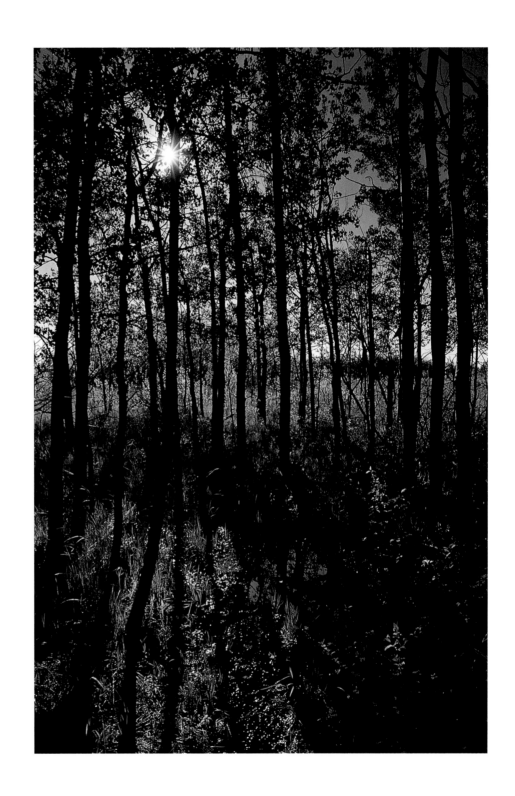

ASPENS AND WILLOWS, HAYDEN
PRAIRIE STATE PRESERVE.

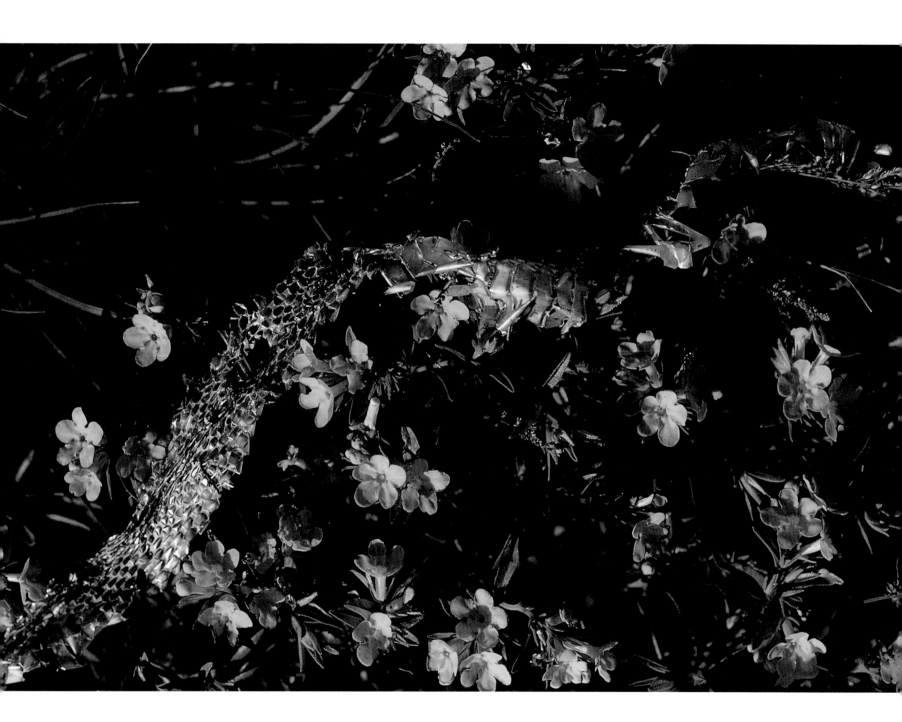

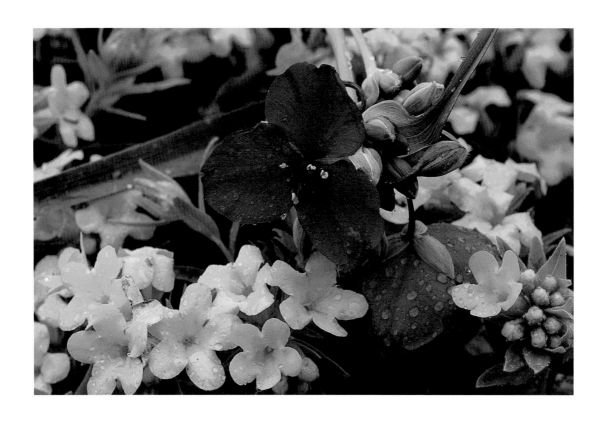

HOARY PUCCOON AND SPIDERWORT, BEARBOWER PRAIRIE.

Opposite: SNAKESKIN AND HAIRY PUCCOON, CEDAR HILLS SAND PRAIRIE STATE PRESERVE.

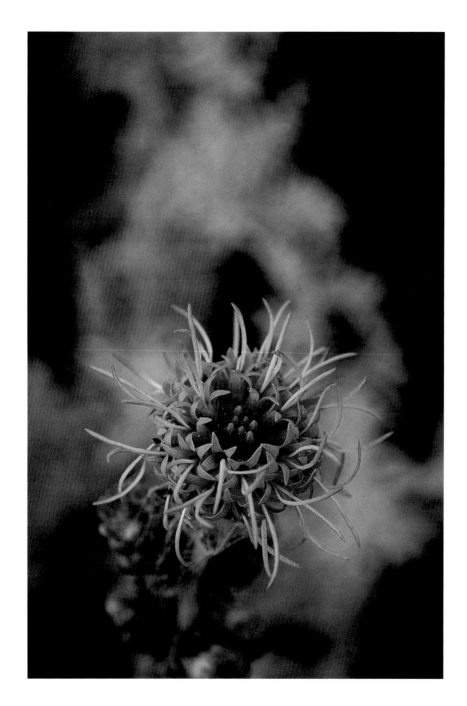

PRAIRIE BLAZING STAR, CEDAR HILLS SAND PRAIRIE STATE PRESERVE.

Opposite: MONARCH BUTTERFLY NECTARING ON ROUGH BLAZING STAR, CEDAR HILLS SAND PRAIRIE STATE PRESERVE.

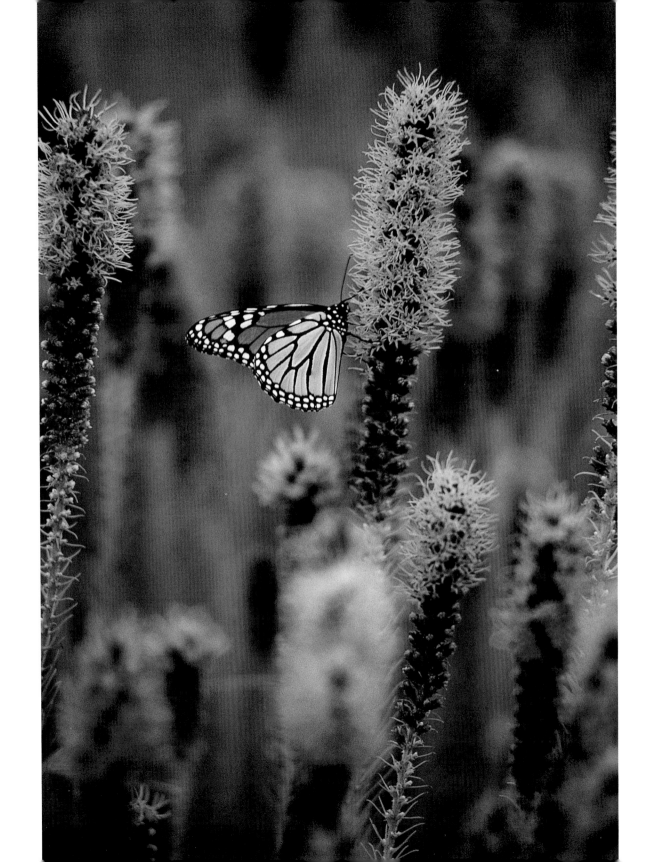

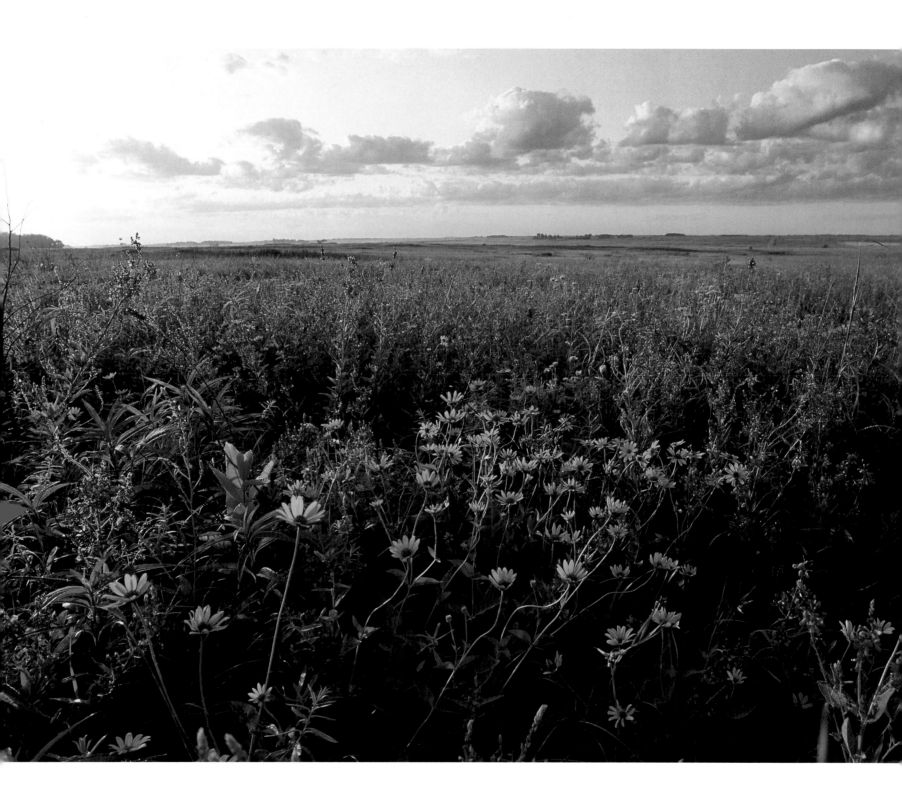

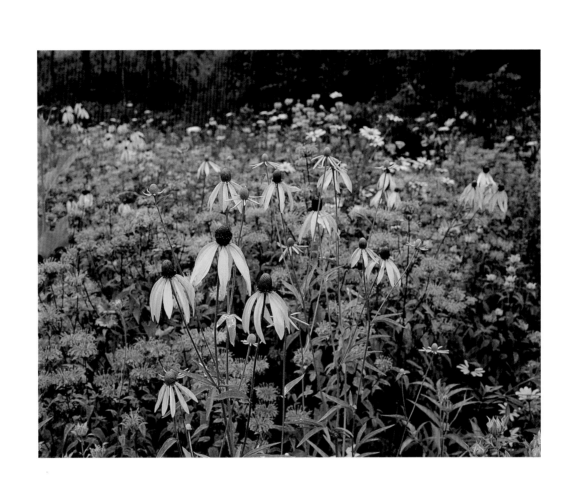

GRAY-HEADED CONEFLOWER AND WILD BERGAMOT, MINES OF SPAIN.

Opposite: SUNFLOWERS AND WINGED LOOSESTRIFE, HAYDEN PRAIRIE STATE PRESERVE.

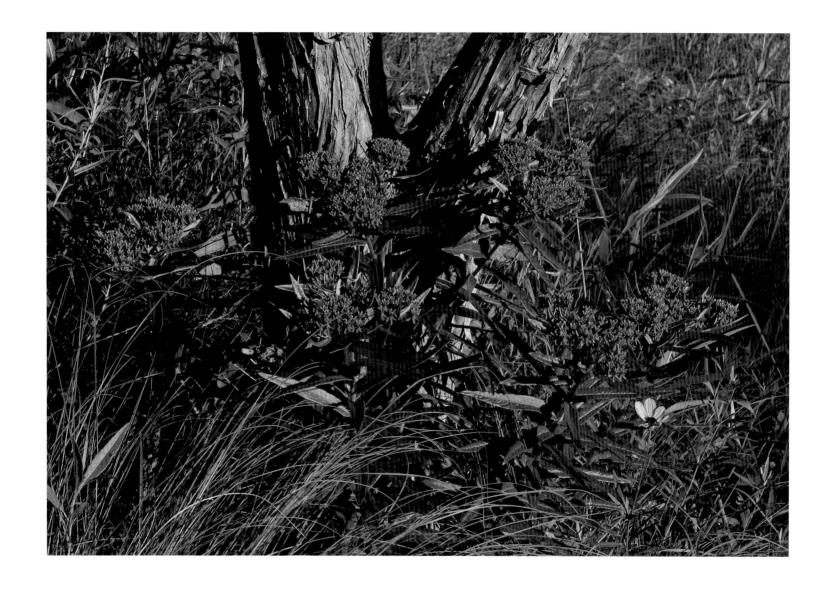

BUTTERFLY MILKWEED ON HILL PRAIRIE, UPPER IOWA RIVER VALLEY.

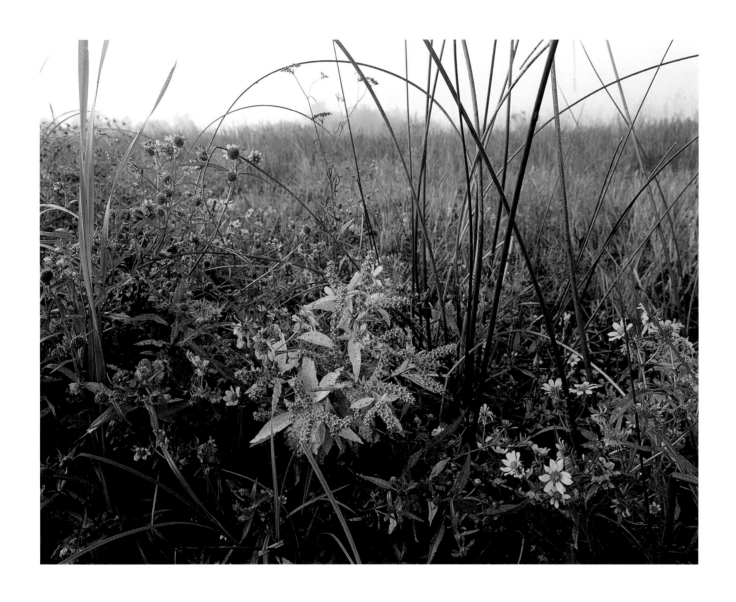

SWAMP SMARTWEED AND PRAIRIE CORDGRASS, CEDAR HILLS SAND PRAIRIE STATE PRESERVE.

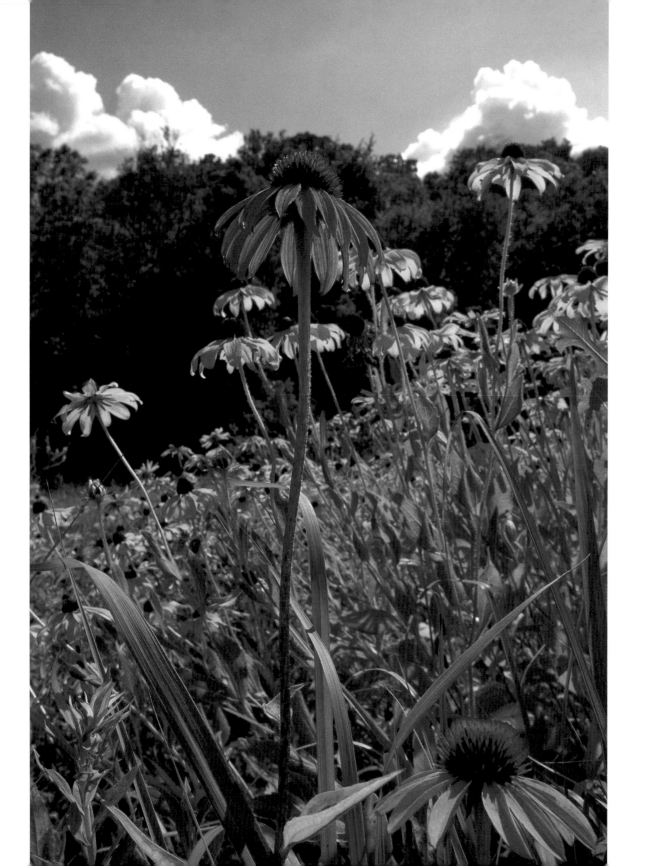

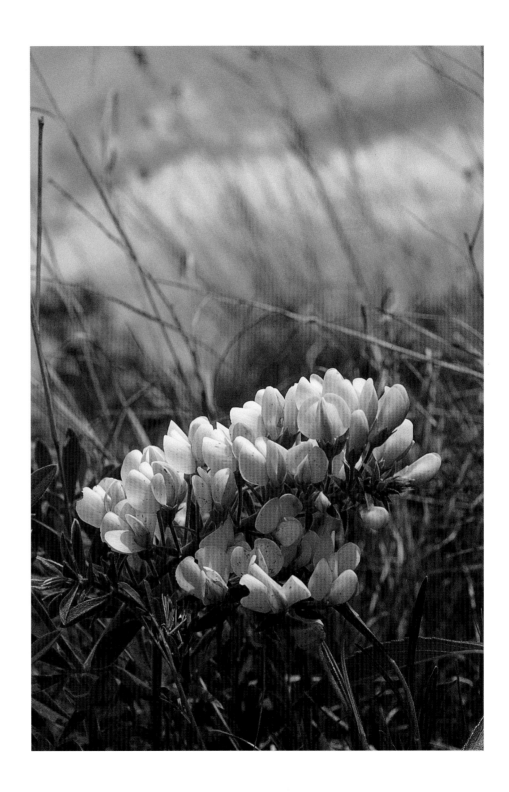

Opposite: PURPLE CONEFLOWER AND BLACK-EYED SUSAN, MINES OF SPAIN.

This page: CREAM WILD INDIGO, SHEEDER PRAIRIE STATE PRESERVE.

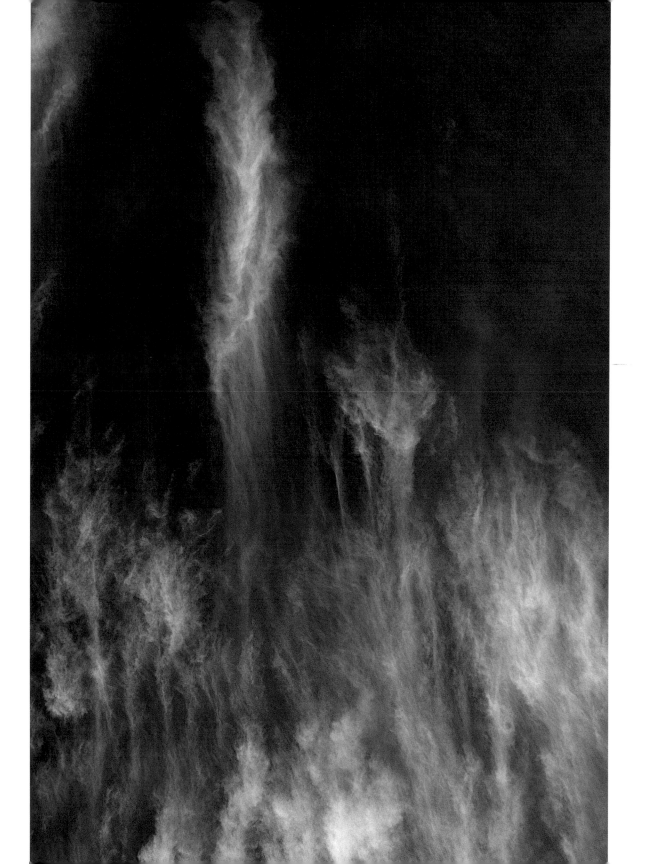

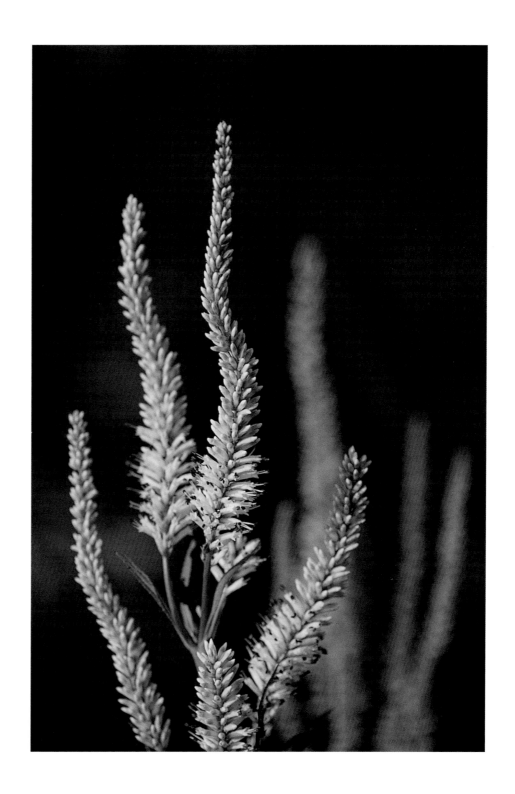

CULVER'S ROOT.

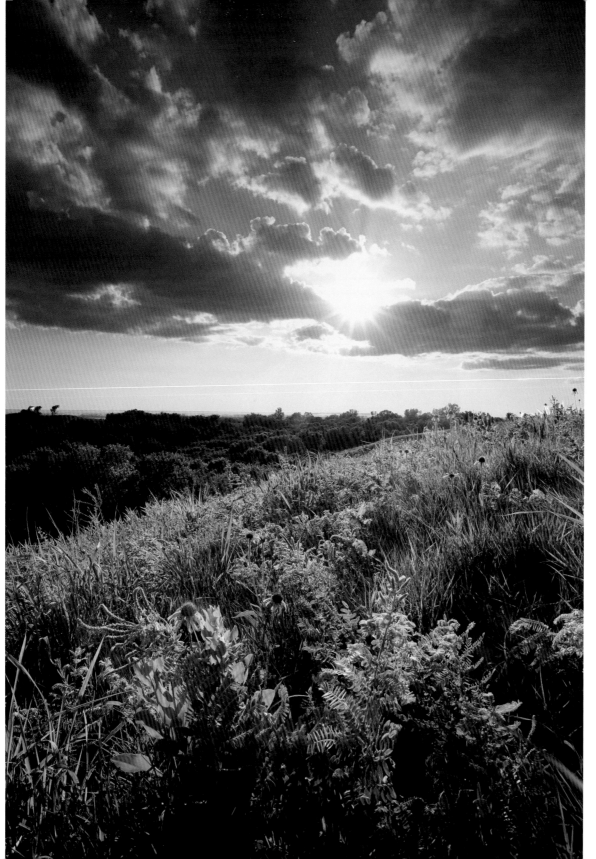

PALE PURPLE
CONEFLOWER AND LEAD
PLANT, MOUNT TALBOT
STATE PRESERVE.

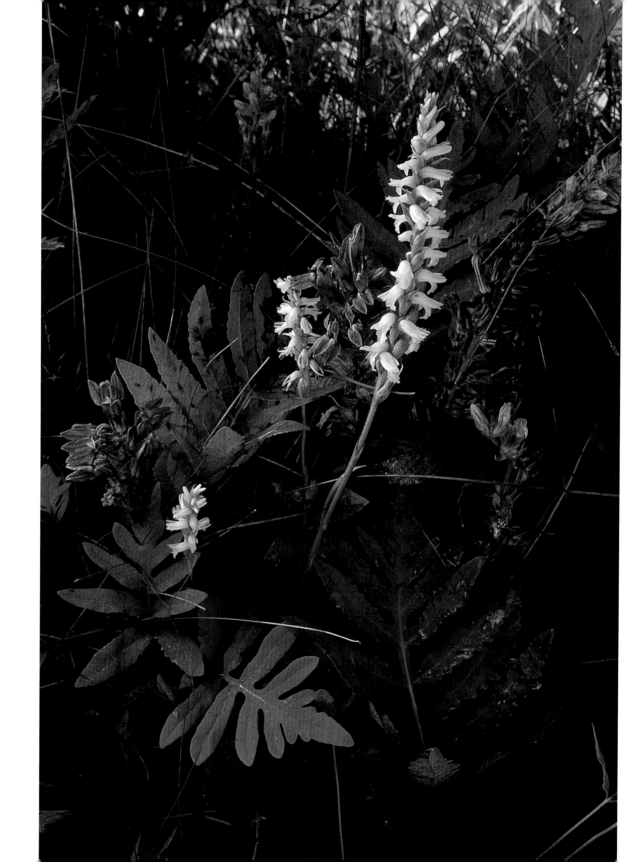

NODDING LADIES'-
TRESSES AND GREAT
LOBELIA.

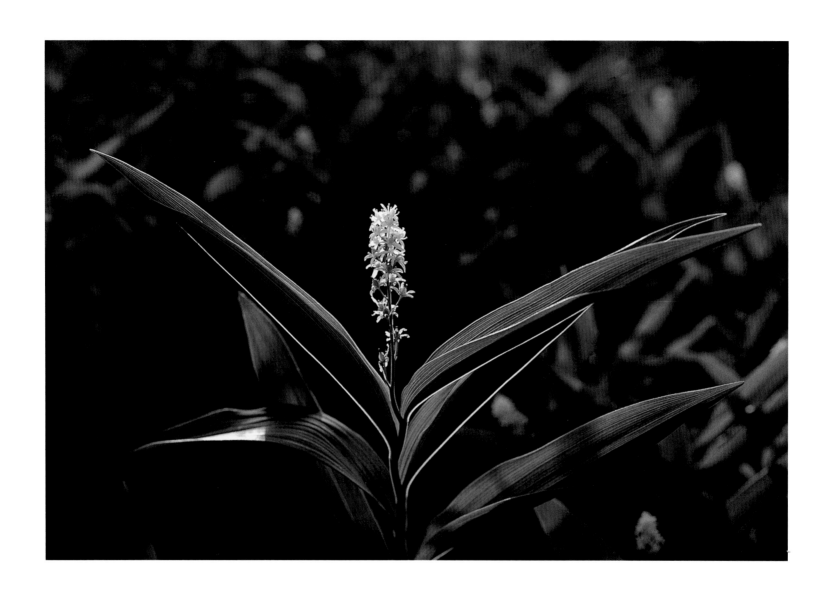

STARRY FALSE SOLOMON'S SEAL, CEDAR HILLS SAND PRAIRIE STATE PRESERVE.

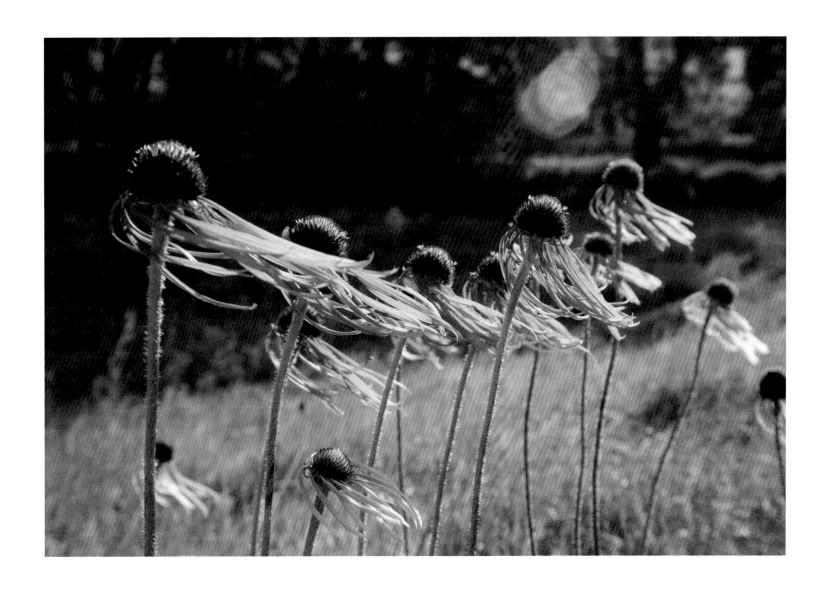

CONEFLOWER CHORINES, BLACKMUN PRAIRIE.

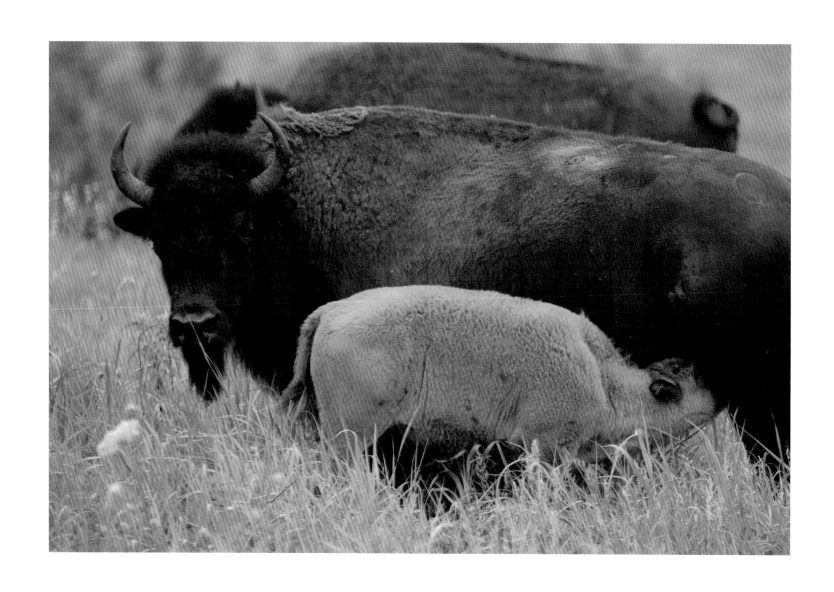

BISON COW AND CALF, NEAL SMITH NATIONAL WILDLIFE REFUGE.

Opposite: NORTHERN HARRIERS, ADULT FEMALE AND JUVENILE.

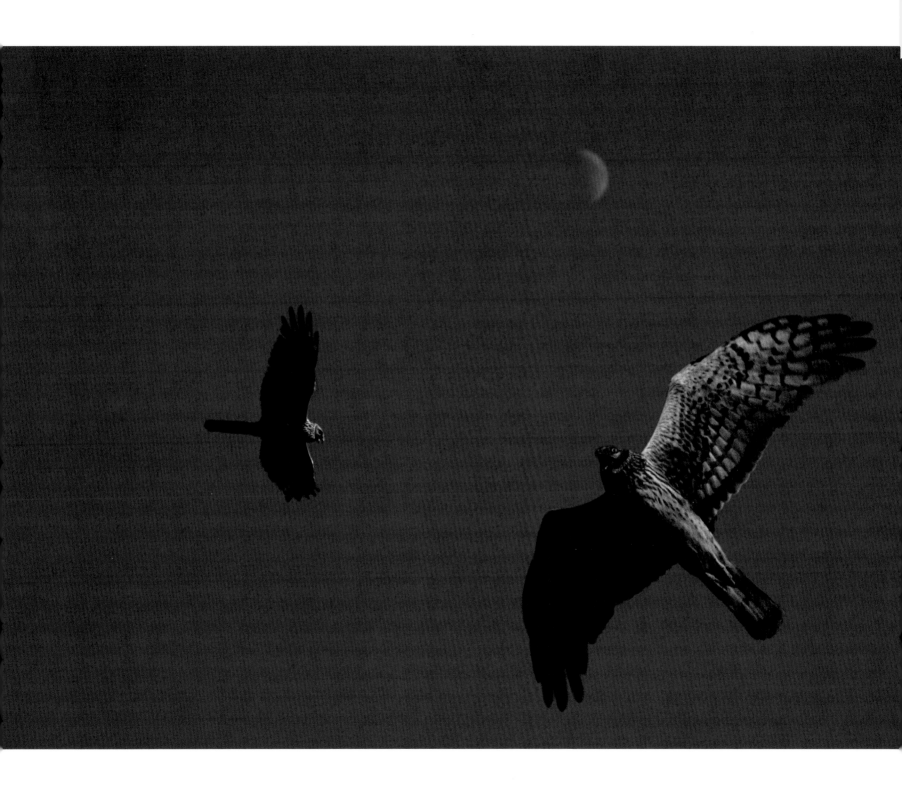

IRIS AT MOONRISE, KING-STILES PRAIRIE.

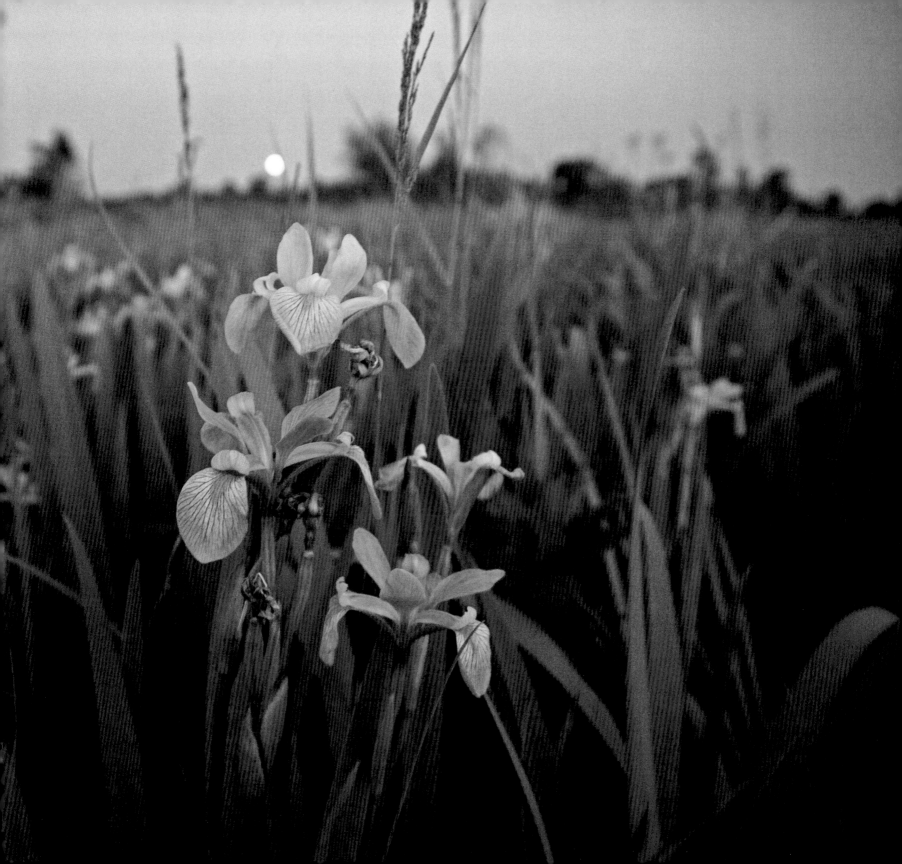

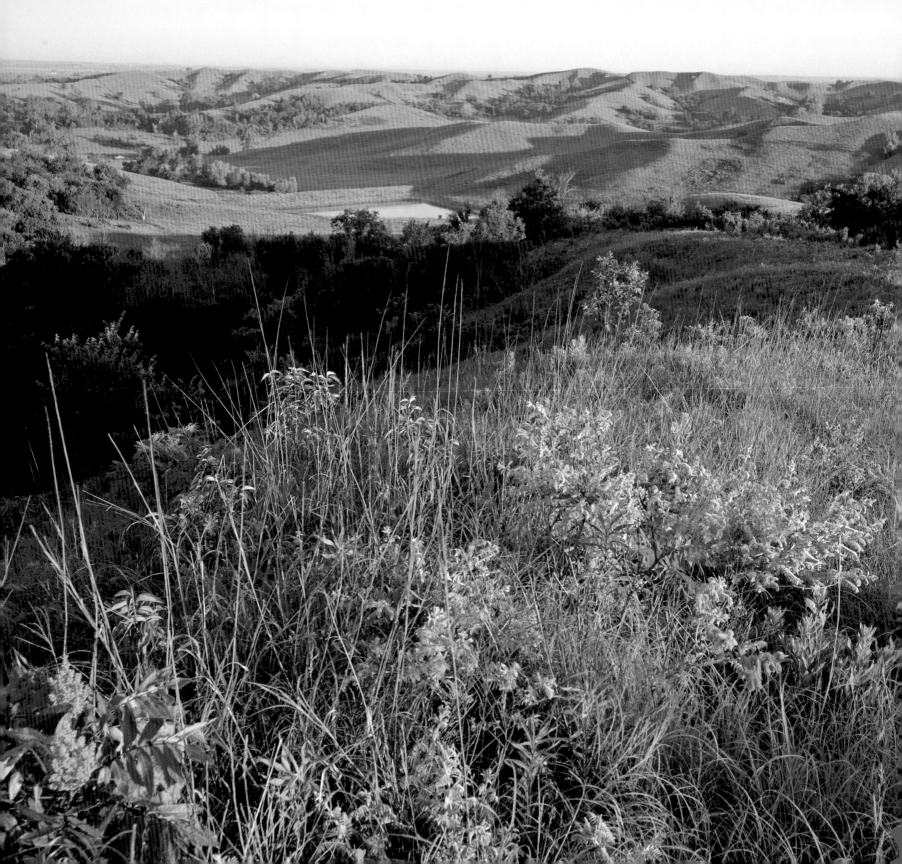

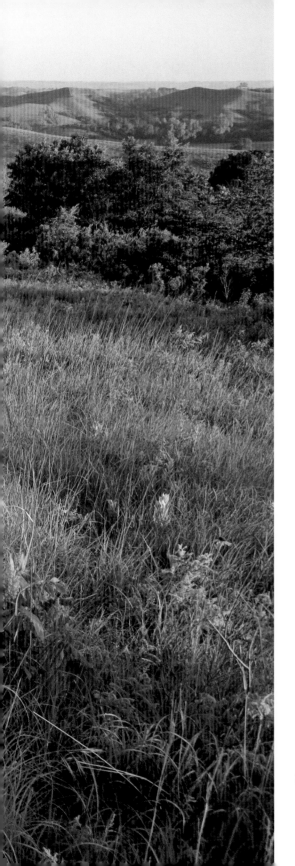

BROKEN KETTLE GRASSLANDS.

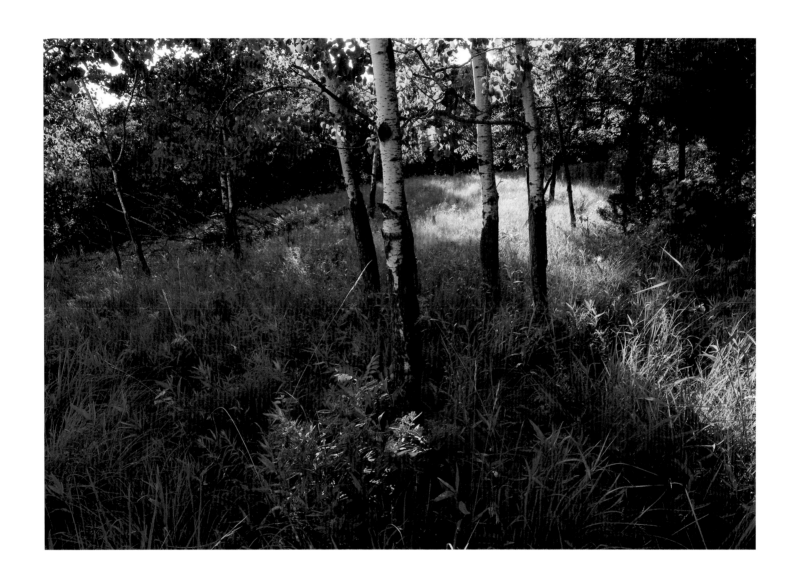

BUTTERFLY MILKWEED IN AN ASPEN GROVE, UPPER IOWA RIVER VALLEY.

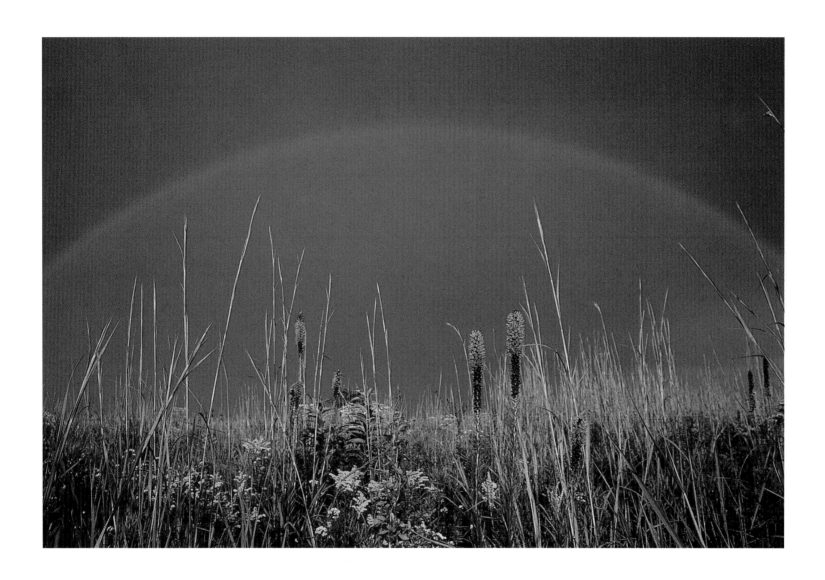

RAINBOW AT CEDAR HILLS SAND PRAIRIE STATE PRESERVE.

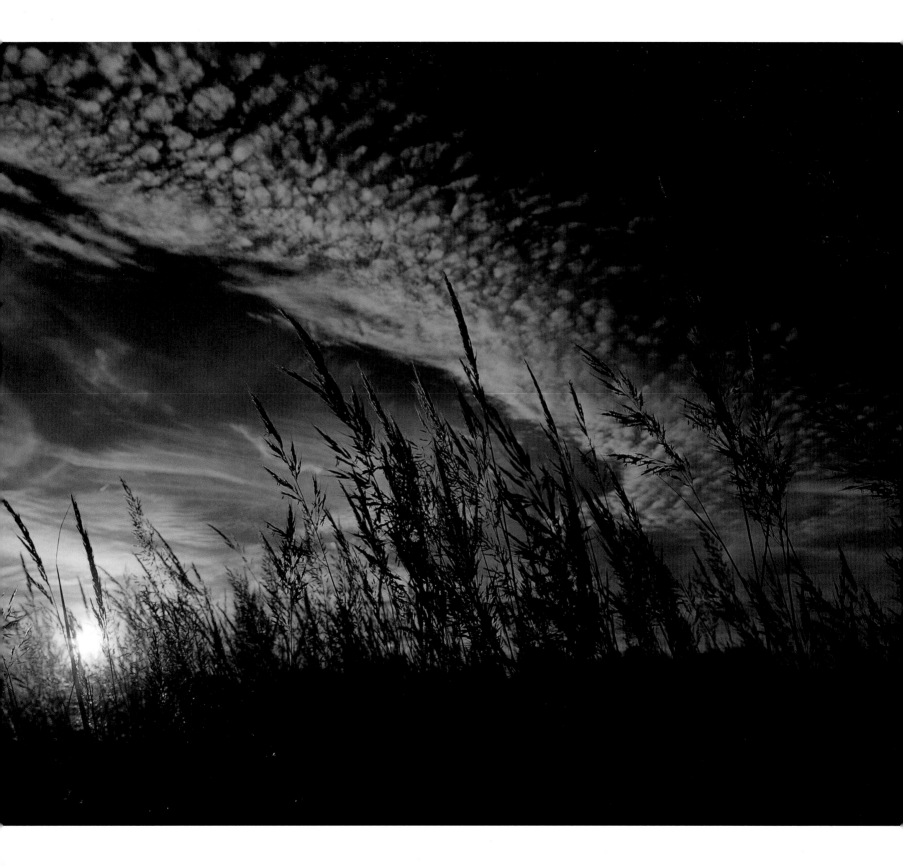

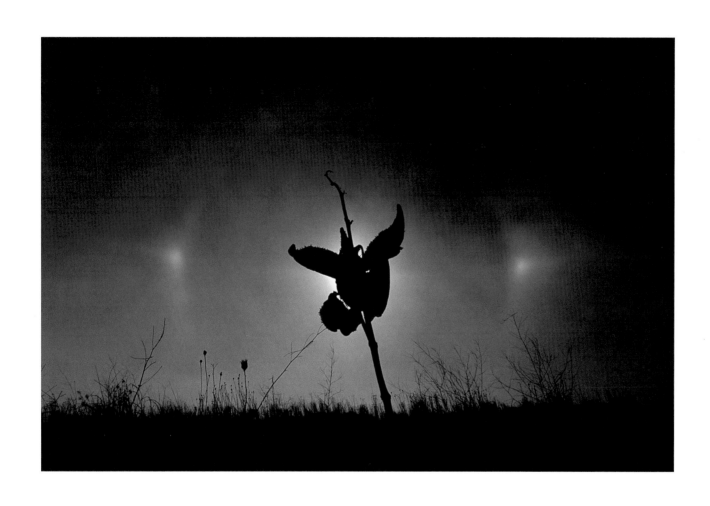

SUNDOGS AND MILKWEED POD, BLACK HAWK COUNTY.

Opposite: INDIAN GRASS AT SUNSET, DOOLITTLE PRAIRIE STATE PRESERVE.

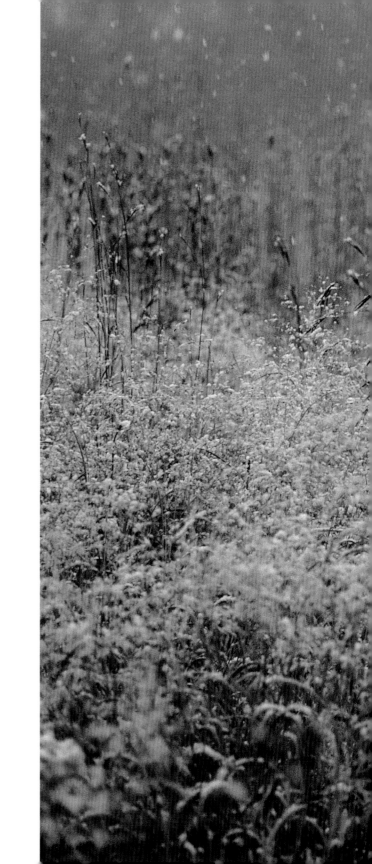

EVENING SNOWFALL, UNIVERSITY OF NORTHERN IOWA PRAIRIE PRESERVE.

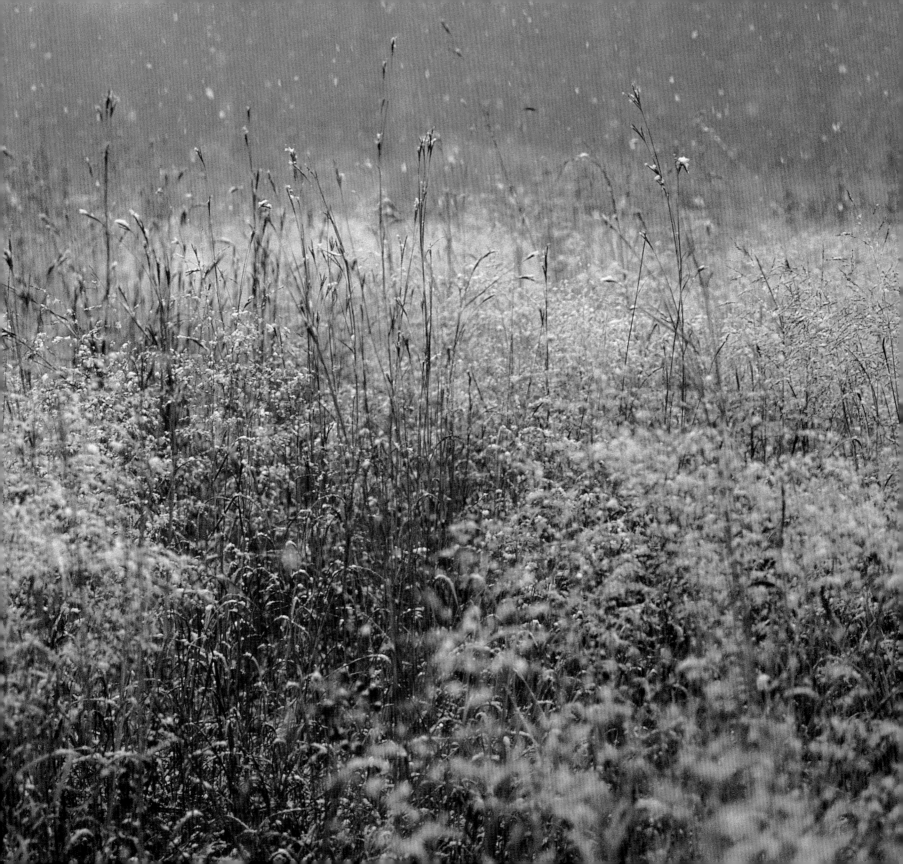

Enchantment by Prairie

BILL WITT

This book is not meant to be a study of prairie places. I have tried to shape it instead as
a meditation on place, on how the experience of prairie affects us when we walk—alert,
attentive, alive amid a plenitude of grasses and flowers beneath a sweeping sky, or through
the still-warm ashes of a fire, or on a winter's bitter morning when ice shatters like glass at
each step—and how we hold it in our memories when we are elsewhere.

That we find ourselves continually "elsewhere" is a basic fact of living for most of
us; prairies are removed from our places of work, commerce, society, family, daily
nourishment, and nightly rest. Given the fecundity of prairie soils and the diligence with
plow and dredge of our farming forebears, prairies could not survive anywhere but by
some sort of separation from so much toiling. That remnants of any size and biological
scope can still persist in North America's most industrialized agricultural landscape seems
improbable, almost miraculous.

Yet the prairie persists. Many times, the silphiums, sorgastrums, and psycodes survive
because in this or that spot Earth would not yield. The fen drowned the tile, the rock broke

the plow. In other prairie places, sanctuaries for pioneer bones below ground assured safety for living roots, stems, and blossoms above. In still others, conservative pasturing practices and family traditions kept prairie from the plow. My mother, who is eighty-five as I write this, still recalls how a few acres of native prairie on the north edge of her father's farm provided just enough pasture to feed his dairy cows and beef cattle through the terrible drought of 1936, keeping their family from economic ruin and putting them at the forefront of rebounding prosperity in the following years.

These kinds of prairie survivals fit, however, in the general realm of social or economic happenstance, like a surveyor's error or a disputed land title or an intractable probate battle. They do not resemble anything miraculous, that source of sudden inner calm and speechless gratitude which Jim and Alice Wilson in their book *Grass Land* mused upon, "a mysterious something . . . a power, a spirit, a mystique, that both stirs the soul and quiets it." But the power of native prairie is real, it does inspire awe and delight and reverence, and it has done so from our very first encounters with it.

By one of those small acts of providence, some thirty years ago I received an inheritance that cannot be calculated in acres or dollars but whose value is immense: a gift of words, written from the heart by an Iowa farm boy in the middle of the Civil War. Orville Williams was a corporal in the Third Iowa Battery, attached to the Ninth Iowa Volunteer Infantry. His unit saw long marches and heavy fighting in Missouri, Arkansas, and

Mississippi. Some of his fights are still in the history books—Huntsville, Pea Ridge, Yazoo Pass—others are forgotten by all but specialists and may be more memorialized in his letters than anywhere else. He wasn't wounded, but from time to time he reported recovering from dysentery, malaria, and "the janders" (jaundice or hepatitis); he was a battle-hardened soldier and a physically tough young man. Of all children of the Iowa prairie who have found themselves "elsewhere," Corporal Orville Williams was likely as far from home as it's possible to be.

On June 20, 1862, after three months of marching and fighting across northern Arkansas, he wrote that "it was some 200, two hundred, miles of hard walking . . . over some of the roughest hills you ever saw, timber all the way. In fact, I have not seen a prairie since I left my old favorite state, the state of Iowa."

Almost a year would pass before Williams did finally encounter prairie again, and his words of May 16, 1863, enclose a rush of memories and feelings: "That night we camped on the edge of what is called Big Prairie. Next morning we started across the prairie. How quick it brought back to my mind the prairies of Iowa. It was the first I had seen since leaveing home, and it recalled to my mind the thoughts of home and its manny pleasures. The thought came to my mind then and there, would I ever be permitted to see home and friends once more. Time, the ever rolling time will tell. While crossing we had some little sport running horses of which I am proud to say my old Bally come off best. We would

occasionally pass through small skirts of timber, but very often we could see the whole length of the column, from the rear guard to the advance. . . . As the advance come out on the prairie, they saw some bushwhackers and started after them, but they took to the woods and got away."

Consider, here are battle-weary troopers, almost two years gone from the open country of Butler and Black Hawk and Buchanan counties, now invading and occupying hostile territory. Then on a May morning the Iowa boys light on a stretch of prairie, a big swath some five miles across. Williams's first thoughts are of longing, homesickness. Next he grows prayerful, then resigned to what fate will bring him. And then? The Iowa boys forget all caution. Williams and his friends abandon military discipline. With whoops of joy they spur their horses and race across this beautiful prairie, this embodied vision of home.

Corporal Williams becomes for a few moments simply Orville Williams, Iowan, twenty-four years old, astride a fast horse, reveling with the wind and the scent of grasses and flowers. For a few moments, Arkansas and Army vanish from his thoughts, and he and his horse are home again. He is a young man oblivious to hardship and imminent danger. He is a man enchanted by prairie.

Prairie has that power to delight, inspire reverie, move us to prayer. Sometimes it

can steal deep into our "elsewhereness" and astonish us. For several years I owned and occupied an old house in the heart of Cedar Falls. Built in 1876, it was surrounded by land that had been settled and farmed and built on and developed with gas, water, sewer, and electric lines ever since the 1850s. But one spring I neglected to mow a little strip of grass that lay between my compost pile and my neighbor's ancient peony hedge. When I finally got around to cutting it, the grass had grown beyond the power of my musculature and my silent-reel push mower, so I went forth with a sickle. I waded into the verdure, and there in the knee-high grass were one . . . two . . . five . . . nine . . . a dozen! stems of blue-eyed grass in full bloom. I stood transfixed by this bouquet of tiny wild irises, here where people had been corn-tilling and lawn-tinkering for more than a hundred years.

Someone, long ago, must have treasured these living sapphires and had either planted them and nurtured them or had let them stay where they had made a home for themselves. Then—for how long?—they had been treated like mere lawn grass, mowed and mowed, never allowed to flower, until I neglected my chores on that out-of-the-way strip of sod and yielded an opening to prairie to enchant me.

Enchantment. Sometimes it's hard to be clear about it, because our endlessly commodifying culture ceaselessly markets the notion that "enchantment" means "entertainment." Yes, there is much genuine entertainment to be found, especially in the

loving enjoyment of our fellow humans—in honest, enduring relationships with our friends and families. But too many "entertainments" consist mostly of packaging, something bought and sold, designed to be experienced and then filed away under "been there." Las Vegas chorines and Disney World mascots and Branson balladeers entertain: we pay, we watch, we listen, we leave.

But the performance of a prairie is something altogether different; its dance and song go on whether or not we are there to watch and listen. We do not write prairie's original script; it has been correcting and revising itself for ten thousand years. To walk through an acre of shooting stars at Hayden Prairie on a bright morning in late May and find one's jeans chalked golden with pollen is enchantment. To lie on one's back on a bright September afternoon with a whorl of prairie dropseed for a pillow, to drowse and then awake to a sound like gentlest rain, which is not rain but the fall of ripened seeds from big bluestem and switchgrass five feet above, is enchantment.

Enchantment is about the magic of *reality*. Prairie is a real place, a living creation; it doesn't advertise. It has the integrity of ancient ways that constantly generate new life in beautiful forms. In its blooming, in its fact of being, it invites us, "Come and know me better." The prairie connects with all our senses, gives us the liberty to appreciate and understand it, to express reverence and joy. It gives us leave to be ourselves. To be at peace.

Prairie invites us to belong, to develop an honest, enduring relationship with this land, our land.

And if we accept the invitation, then comes also a call to obligation. In *Arctic Dreams* Barry Lopez writes, "For a relationship with landscape to be lasting, it must be reciprocal. In approaching the land with an attitude of obligation, willing to observe courtesies difficult to articulate, perhaps with only a gesture of the hands, one establishes a regard from which dignity can emerge. From that dignified relationship with the land, it is possible to imagine an extension of dignified relationships throughout one's life."

When I found my blue-eyed grass, I don't remember if in my astonishment I made a dignified gesture. But I do know that for all the ensuing early springtimes that I continued living there, I let that little strip of ground go uncut, and the blue-eyed grass continued to flower and ripen seed. I know, too, that in our culture fixated and slowly foundering on its assumptions of materialism, more of us are becoming dissatisfied with the fruits of those assumptions. Where do we find our hope when we are so confused, so driven by materialism? We find it where we can offer a dignified gesture, where we can work to plant seeds and send down roots.

We are sending down roots in a landscape that also has its terrors and trials—its blizzards, tornadoes, torrents of rain and flood, its minus-30- and plus-100-degree days. But ultimately, it's an open and inviting landscape, an abundant and genially spiritual one. It conduces to hope in a way that the rocky slopes of New England or the deserts of

California do not, maybe cannot. Rightly perceived and respectfully encountered, prairie is an affirming land.

We have here a chance to establish a reciprocal relationship with this prairie, our land. There is a powerful presence in our prairies, and when we connect with it we are better people for it.

"We have been telling ourselves the story of what we represent in the land for 40,000 years," says Barry Lopez. "At the heart of this story is a simple abiding belief: It is possible to live wisely on the land and to live well, and in behaving respectfully toward all that the land contains, it is possible to imagine a stifling ignorance falling away from us."

One of Iowa's own, Arnold Webster, said it more simply. "An hour alone on a prairie will wash the meanness out of your soul."

Prairie has persisted, physically, all around us in far greater quantities than we could have hoped. It has also persisted in our hearts and in our minds. Prairie connects us to the beauty and the abiding power of creation in its fullness and wholeness. And it reconnects us to those forces that helped us become an abiding people: tolerant, compassionate, insightful, resourceful, modest, honest, just. Native prairie inspires us and feeds our hunger for enchantment. Ultimately, it challenges us to restore the spiritual carrying capacity of our earth.

If we accomplish that, everything else will follow.

Other Bur Oak Books of Interest

The Butterflies of Iowa
By Dennis W. Schlicht, John C. Downey, and Jeffrey Nekola

A Country So Full of Game: The Story of Wildlife in Iowa
By James J. Dinsmore

The Elemental Prairie: Sixty Tallgrass Plants
By George Olson and John Madson

The Emerald Horizon: The History of Nature in Iowa
By Cornelia F. Mutel

Fifty Common Birds of the Upper Midwest
By Dana Gardner and Nancy Overcott

Fifty Uncommon Birds of the Upper Midwest
By Dana Gardner and Nancy Overcott

Fragile Giants: A Natural History of the Loess Hills
By Cornelia F. Mutel

An Illustrated Guide to Iowa Prairie Plants
By Paul Christiansen and Mark Müller

Iowa Birdlife
By Gladys Black

The Iowa Breeding Bird Atlas
By Laura Spess Jackson, Carol A. Thompson, and James J. Dinsmore

The Iowa Nature Calendar
By Jean C. Prior and James Sandrock

Landforms of Iowa
By Jean C. Prior

Orchids in Your Pocket: A Guide to the Native Orchids of Iowa
By Bill Witt

A Practical Guide to Prairie Reconstruction
By Carl Kurtz

Prairie: A North American Guide
By Suzanne Winckler

Prairie in Your Pocket: A Guide to Plants of the Tallgrass Prairie
By Mark Müller

Restoring the Tallgrass Prairie: An Illustrated Manual for Iowa and the Upper Midwest
By Shirley Shirley

A Tallgrass Prairie Alphabet
By Claudia McGehee

The Vascular Plants of Iowa: An Annotated Checklist and Natural History
By Lawrence J. Eilers and Dean M. Roosa

Where the Sky Began: Land of the Tallgrass Prairie
By John Madson